Traditions in Transition: Change and Material Culture in 19th-Century Texas, the Lower South, and the Southwest

The David B. Warren Symposium

Volume 6

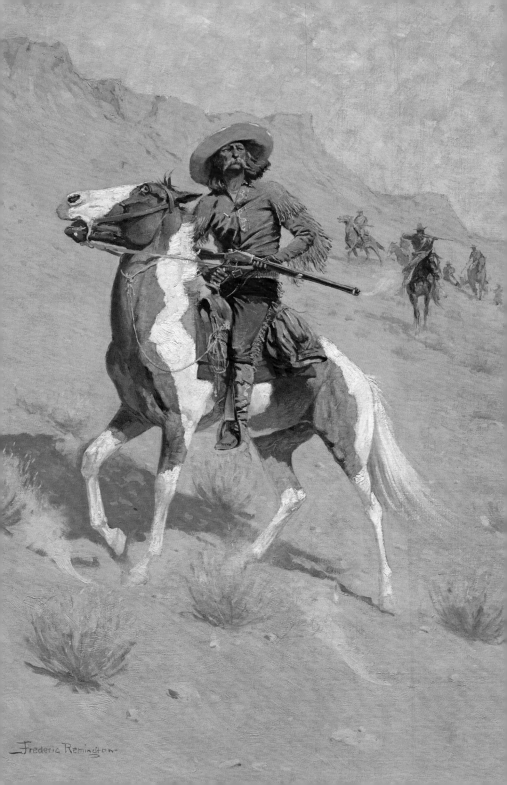

Frederic Remington

Traditions in Transition: Change and Material Culture in 19th-Century Texas, the Lower South, and the Southwest

The David B. Warren Symposium

Volume 6

Bayou Bend Collection and Gardens
The Museum of Fine Arts, Houston

Publisher in Chief: Diane Lovejoy
Edited by Heather Brand
Book design by Amy Carder Elliott
Printing by Masterpiece Litho, Inc.

Printed in the United States of America

Library of Congress Cataloging-in-Publication Data

Names: David B. Warren Symposium (6th : 2017 : Museum of Fine Arts, Houston), author.
Title: Traditions in transition : change and material culture in 19th-century Texas,
 the lower South, and the Southwest : The David B. Warren Symposium, volume 6
Description: Houston : The Museum of Fine Arts, Houston, 2017. | Series: Includes
 bibliographical references.
Identifiers: LCCN 2017033033 | ISBN 9780890901939 (pbk.)
Subjects: LCSH: Art and society—Southern States—History—19th century—Congresses. | Art
 and society—Texas—History—19th century—Congresses.
Classification: LCC N72.S6 D36 2017 | DDC 701/.03—dc23 LC record available at
 https://lccn.loc.gov/2017033033

Cover: Hermann Lungkwitz, *Hill Country Landscape* (detail), 1862, oil on canvas, 18 ⅜ × 23 ⅞ in. (46.7 × 60.5 cm), the Museum of Fine Arts, Houston, the Bayou Bend Collection, gift of Miss Ima Hogg, B.67.39.

Back cover: Shop of Johann Michael Jahn, probably made by Carl Andreas Jahn, *Stand*, New Braunfels, Texas, c. 1880, black walnut, 29 x 15 in. diameter (73.7 x 38.1 cm), the Museum of Fine Arts, Houston, the Bayou Bend Collection, gift of William J. Hill, B.2007.19.

Frontispiece: Fredrick Remington, *The Scout*, c. 1902, oil on canvas, 40 x 27 ½ in. (101.6 x 69.9 cm), the Museum of Fine Arts, Houston, bequest of Charlene Quitter Thompson, 2013.653.

Pages viii and xi: William Otto Glosnop, *Sewing Table*, Clarksville, Texas, 1877, walnut, cedar, unidentified woods, and porcelain, 34 ½ x 26 ½ in. diameter (87.6 x 67.3 cm), the Museum of Fine Arts, Houston, the Bayou Bend Collection, gift of William J. Hill, B.2017.1.

The 2017 David B. Warren Symposium at Bayou Bend received generous funding from:
The David B. Warren Symposium Endowment
Mr. William J. Hill
Mrs. Nancy Glanville Jewell
Humanities Texas, the state affiliate of the National Endowment for the Humanities
Mrs. Fred R. Lummis
Bobbie and John Nau
The Summerlee Foundation

If you would like to support the Endowment Fund for the biennial David B. Warren Symposium, please send your contributions to Bayou Bend Collection and Gardens, P. O. Box 6826, Houston, Texas, 77265-6826.

Contents

ix Foreword
Bonnie A. Campbell

1 The Paintings of Hermann Lungkwitz
as a Type of Texas Material Culture
Kenneth Hafertepe

27 On the Edge: The Neill-Cochran House,
the Late Antebellum Era, and the Changing
Face of Texas
Rowena Houghton Dasch

47 From the Palaces of Berlin to the Texas Frontier:
The Furniture Designs of Prussian Architect
Karl Friedrich Schinkel
Serena Newmark

67 Making the Texas Cowboy and
the Tools of the Endeavor
Bruce M. Shackelford

95 Portraits of Slaves in a New South
Jennifer Van Horn

121 Contributors

123 Photograph Credits

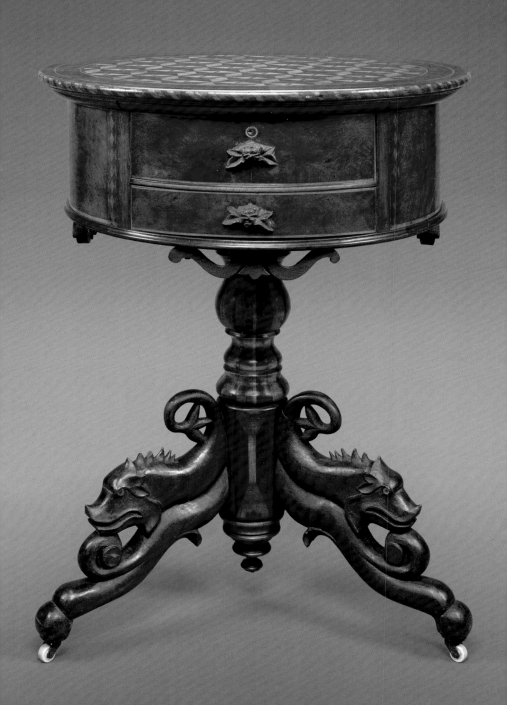

Foreword

My foreword to the 2016 symposium proceedings described the year as celebratory, marking the fiftieth anniversary of Bayou Bend's opening to the public. The year 2017 saw us entering our second half-century of tours, public programs, and scholarship with enthusiasm and forward-looking plans. Bayou Bend's collection and gardens had never been more impressive, or looked more beautiful.

And then Hurricane Harvey descended with record-breaking force on South Texas, Houston, and Bayou Bend. On August 27, Buffalo Bayou, which encircles more than half of our fourteen-acre property, rose sixty-five feet above its normal level. The bayou no longer "bended," and the north side of the grounds was completely flooded, the water nearly reaching the mansion's first floor. As I write this in mid-November, Bayou Bend remains closed to the public. Mechanical and electrical systems are all being replaced. The historic gardens are being cleared of endless bayou silt and debris. Damaged and stressed plantings and trees continue to require careful attention.

One might assume amid all of the destruction and costly repairs that the word "celebratory" could not possibly be used to describe this year. Yet, we most wholeheartedly do celebrate that the collection of decorative arts and paintings inside the house is safe and secure. And we remember that Bayou Bend has weathered many hurricanes and floods, the first in 1929, less than a year after its completion. In fact, in the 1930s, flood-waters rose more than four feet on the first floor. Ima Hogg, the founder of Bayou Bend, persevered, and so shall we. As Houston recovers, we cannot help but be inspired by the Texas spirit that has shaped our history.

I chose to illustrate this Texas-made table here because it is imbued with a similar Texas spirit of optimism and celebration. A tour de force of craftsmanship and Texas pride, the table was entered by German-born immigrant William Otto Glosnop into the 1877 Third Annual Exposition of the Capital State Fair, where it won an award—"Best Center Table, Manufactured in Texas of Texas Wood." The table was our first acquisition of 2017, thanks to the generosity of Texas collector William J. Hill, who gave it to us.

One of the most beautiful and significant examples of early Texas furniture in the Bayou Bend Collection, the table survived 140 years before coming to Bayou Bend, and it held its own throughout Hurricane Harvey, located in a place of honor in the second-floor "Texas Room." It reminds us that the material culture of nineteenth-century Texas has always been integral to the Bayou Bend Collection, a field of study that Ima Hogg championed long before most collectors and scholars. The table reflects a progression

of dedicated research, appreciation, and collecting at Bayou Bend: from Miss Hogg's creation of the Texas Room in the 1960s; to the 1970s publication—at her encouragement—of a seminal book on Texas furniture; to the decades-long increase of Texas-made objects in the collection; to the inaugural David B. Warren Symposium in 2007; to our 2012 launch of an Internet archives database devoted to early Texas artisans and artists; and to publications on nineteenth-century Texas pottery (2015) and silver (2016).

The present volume represents our continuing dedication to promoting scholarship. It contains the five papers delivered at the sixth biennial David B. Warren Symposium, held at the Museum of Fine Arts, Houston, on February 24–25, 2017, in response to a national call for presentations that reflect the broad theme of "Traditions in Transition: Change and Material Culture in 19th-Century Texas, the Lower South, and the Southwest." Noted Texas scholar Ken Hafertepe's opening address uses the iconic paintings of immigrant artist Hermann Lungkwitz to provide an introduction and context for the conference's premise of "traditions in transition." Rowena Houghton Dasch builds her thesis on the changing face of Texas around the architecture of a nineteenth-century Austin landmark. Serena Newmark provides an intriguing international link to Texas material culture, proposing a connection between Central European furniture traditions and the objects made by immigrants from those areas to Texas. Bruce Shackelford offers another international connection in his paper, discussing the impact of the Hispanic tradition on ranching and cowboy culture in Texas. Jennifer Van Horn provides new insights into early Southern portraiture, focusing on images of slaves, and reminding us that the symposium's parameters extend beyond the Texas border. As with all previous five volumes, we will disseminate complimentary copies of this volume of symposium proceedings to more than 250 research libraries across the nation.

I am indebted to the Bayou Bend education department and many other Bayou Bend staff and museum professionals who once again organized and implemented a fascinating, successful symposium. Special recognition as well to the advisory committee, which helped select the theme and the speakers for the symposium, including three longtime and legendary Texas scholars, Lonn Taylor, Ron Tyler, and David Warren. However, we could not have presented the 2017 symposium without the steadfast generosity of the following supporters: Mr. William J. Hill; Mrs. Nancy Glanville Jewell; Humanities Texas, the state affiliate of the National Endowment for the Humanities; Mrs. Fred R. Lummis; Bobbie and John Nau; the Summerlee Foundation; and proceeds from the David B. Warren Symposium Endowment Fund.

As post-Harvey Bayou Bend prepares to reopen and celebrate our continuing tradition of sharing this important cultural resource with the public, I trust that readers will indulge my reference to another reason to celebrate Houston's strength and perseverance this year—the Astros' first-ever World Series championship!

Bonnie A. Campbell
Director
Bayou Bend Collection and Gardens

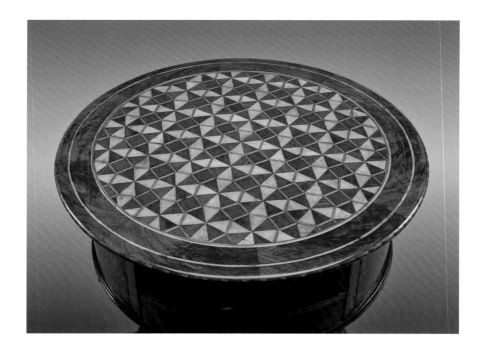

Fig. 1. Hermann Lungkwitz, **Der Marktplatz in Halle im Jahre 1835**, 1835, oil on canvas, 22 ½ x 28 ¾ in. (57.2 x 73 cm), Staatliche Galerie Moritzburg, Halle an der Saale, Germany.

The Paintings of Hermann Lungkwitz as a Type of Texas Material Culture

Kenneth Hafertepe

In 2007 the Museum of Fine Arts, Houston, hosted the first David B. Warren Symposium, titled "American Material Culture and the Texas Experience." In the opening address, Margaretta Lovell explained the difference between material culture and decorative art.[1] She suggested that "material culture is a larger category than 'decorative arts' or 'art'; it is more flexible and less exclusionary then either of those terms. . . . In terms of subject, material culture embraces everything fabricated or manipulated by human intention." The term "less exclusionary" seems to be a gentle way of saying that material culture includes things that are less beautiful or not beautiful at all. Although things that are functional but not beautiful must be included in material culture, this does not mean that things of high aesthetic quality or rarity are *not* material culture.

Lovell also emphasized the importance of tracking the history of an object over time. She embraced the view that objects have a biography, and that later changes can tell us a great deal about changing cultural attitudes toward the object: "Objects are not just evidence of the past, they are the past. As William Faulkner put it, 'the past is never dead. It's not even past.'" She concluded, "The historian's subject is change, and the antiquarian's is stasis." Objects were designed to suit the function and the taste of the moment, and were always susceptible to modification.

What do the works of Hermann Lungkwitz tell us about the changing material culture of early Texas, and what does the material culture of early Texas tell us about the works of Hermann Lungkwitz? Lungkwitz has been discussed in most of the standard works on Texas art; most crucially, James Patrick McGuire's book *Hermann Lungkwitz: Romantic Landscapist on the Texas Frontier* provides a catalogue raisonné of Lungkwitz's

work and a thorough accounting of his life.[2] To go beyond McGuire's version of Lungkwitz's life and work, one must explore the junctures between artistic life and everyday life, and between the Texas that Lungkwitz found when he arrived in 1851 and the Texas that he left upon his death in 1891. Ultimately, one should consider the genres in which Lungkwitz worked, and whether calling him a "Romantic landscapist" tells the whole story. In an essay on Hermann Lungkwitz's art in Texas, his first thirty-seven years spent in Germany can serve only as prologue. His earliest known painted work depicted his hometown of Halle an der Saale in Saxony (fig. 1). His formal training was at the Academy of Fine Arts in Dresden, where he met Friedrich Richard Petri, a fellow student who became a dear friend and whose sister, Elise, Lungkwitz was to marry.[3]

Three German painters exerted a significant influence on Lungkwitz. One was Caspar David Friedrich, the towering figure of early nineteenth-century German Romantic art who explored nature and man's relation to it. However, Friedrich had ceased to teach in 1835, and died in 1840, the year in which Lungkwitz entered the academy. The two others were the faculty members Johan Christian Dahl and Adrian Ludwig Richter.[4] Dahl was a native of Norway who had studied with Friedrich

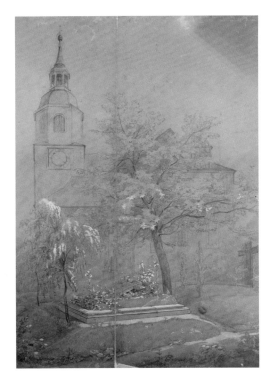

Fig. 2. Hermann Lungkwitz,
The Grave of Louis Pfeiffer,
no date, graphite and crayon on paper,
19 x 16 ½ in. (48.3 x 41.9 cm),
Alfred O. Wupperman Collection,
the Dolph Briscoe Center for American
History, the University of Texas at Austin.

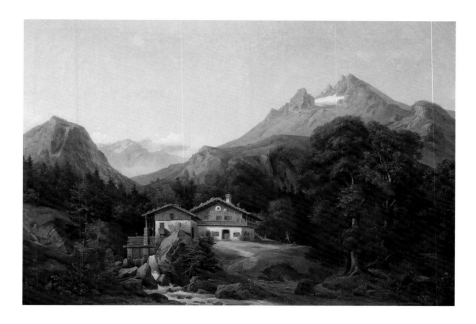

Fig. 3. Hermann Lungkwitz, **Near Berchtesgaden – The Watzmann**, 1845, oil on canvas, 28 x 40 ½ in.
(71.1 x 102.9 cm), collection of James and Kimel Baker.

and had lived with Friedrich's family for a while. His paintings range from depictions of leafless trees and giant stones used as ancient burial sites to landscapes flush with spring color, which also suggest something of the sublime, of the overwhelming power of nature.[5] Richter intentionally distanced himself from the brooding landscapes of Friedrich. His scenes tend to incorporate figures from folktales, or peasants dancing or walking through spring landscapes. He also had an eye for domestic scenes and studies of the human countenance.[6]

In his works of the 1840s, Lungkwitz demonstrated the lessons he had learned from Friedrich, Dahl, and Richter. His drawing *The Grave of Louis Pfeiffer* depicts not only that grave but also the church that looms in the background (fig. 2). On the other hand, his European landscapes, such as *Near Berchtesgaden – The Watzmann* (fig. 3), show him creating his own style, different from versions by Friedrich, Dahl, or Richter. All three artists painted the same subject some twenty years earlier, with interesting differences in approach. Friedrich saw it as a pure landscape, with overpowering forms suggestive of the sublime, an approach that Dahl closely followed. Richter, on the other hand, saw it as a domesticated landscape, dotted with buildings and other evidence of human activity.[7]

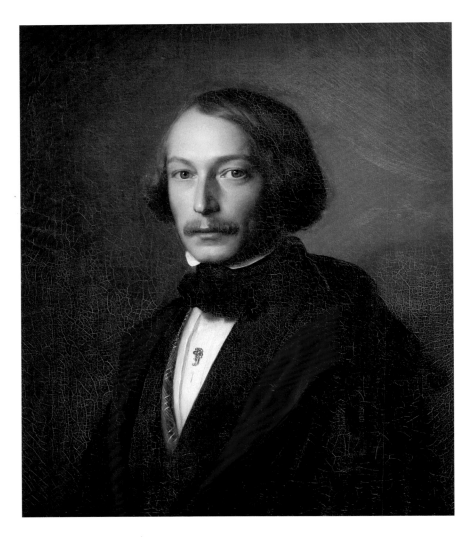

Fig. 4. Friedrich Richard Petri, **Portrait of Hermann Lungkwitz,** *c. 1850, oil on canvas, 23 ¾ x 20 in. (60.3 x 50.8 cm), Texas Governor's Mansion, Austin.*

Opposite page:
Fig. 5. Friedrich Richard Petri, **Hermann and Elisabet [Elise] Lungkwitz Comfort the Twins,** *graphite on paper, the Dolph Briscoe Center for American History, the University of Texas at Austin.*

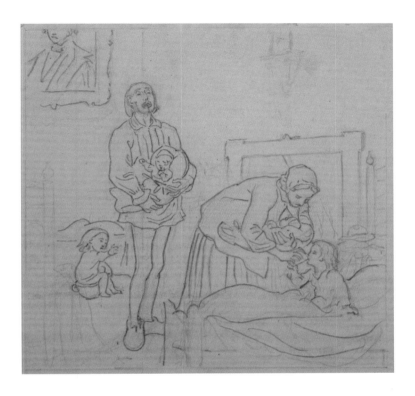

The best surviving image of Lungkwitz is Petri's excellent oil-on-canvas portrait (fig. 4), which now hangs in the Texas Governor's Mansion in Austin. It depicts Lungkwitz as distinguished, well-educated, and urbane, though offering no clue of his profession as an artist—perhaps because both painter and sitter knew that such pursuits would be on hold for the foreseeable future in Texas.[8]

Petri also documented the family's early years in Texas, when they farmed on Live Oak Creek several miles south of Fredericksburg. One small pencil sketch shows challenges of a domestic nature (fig. 5). In 1857 Elise had twins, Alice and Helene, and the family already had two children, Max, age four, and Martha, age two. The addition of two infants was a recipe for sleepless nights, and Petri, the lifelong bachelor, seemed to enjoy depicting Lungkwitz as being near the end of his rope.[9] Yet this sketch also documents how a German pioneer cabin of the 1850s was furnished, with turned chairs and bedposts, and a bracket above the low door, supporting a clock. Furthermore, this sketch documents the placement of Petri's oil-on-canvas formal portrait of Lungkwitz, which hangs in a corner of the log house. Petri clearly relished the contrast of daytime distinction and late-night disturbance.

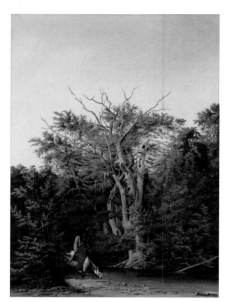

Above, left to right:

Fig. 6. Hermann Lungkwitz, **Sisterdale***, dated July 10, 1853, graphite on paper, 17 x 11 in. (43.2 x 27.9 cm), the Bobbie and John L. Nau Collection.*

Fig. 7. Hermann Lungkwitz, **The Old Pinta Crossing on the Guadalupe***, c. 1852, oil on canvas, 22 x 16 in. (55.9 x 40.6 cm), the Bobbie and John L. Nau Collection.*

Lungkwitz apparently did not return to art making in any meaningful way until 1853. In that year, he traveled to Sisterdale to execute drawings for a lithograph, *Dr. Ernest Kapp's Water-Cure, Comal County, Texas*. This beautifully detailed drawing (fig. 6) is very much in the tradition of Friedrich and his followers. The cypress tree also made an appearance in Lungkwitz's painting *The Old Pinta Crossing on the Guadalupe* (fig. 7), which makes clear that the cypress was on the banks of the Guadalupe River near Sisterdale.[10]

In 1855 Lungkwitz received a major commission from one on his neighbors, Carl Hilmar Guenther (fig. 8). Like Lungkwitz, Guenther was from Saxony, specifically from Weissenfels an der Saale. Guenther was to become a pioneer miller in Texas, the first on Live Oak Creek and later in San Antonio. The painting documents Guenther's progress in Texas. Indeed, he commissioned this painting so he could send it to family members back in Germany. When he had purchased his place, two log houses were already on the premises. Guenther's mill is the central focal point of the painting, and

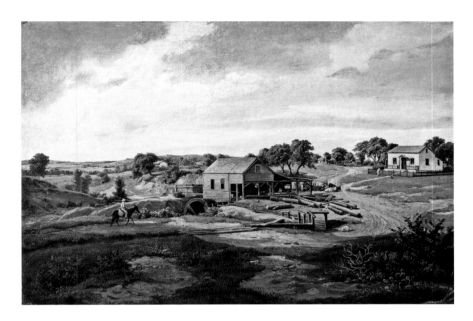

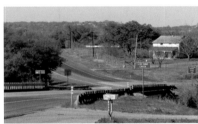

Above:
*Fig. 8. Hermann Lungkwitz, **Guenther's Mill** on Live Oak Creek, 1855, oil on academy board, 13 ½ x 19 ½ in. (34.3 x 49.5 cm), C. H. Guenther & Son, San Antonio.*

Left:
*Fig. 9. **Guenther House and State Highway 16**, April 9, 2014.*

Lungkwitz showed that the mill was capable of sawing trees into lumber as well as grinding flour and cornmeal.[11]

Also prominent is the rock house that Guenther had recently built for his bride-to-be, Dorothea Pape. The painting depicts a typical kind of German-Texan house, with a single front room (a *stube*) and a back room used either as the kitchen or a bedchamber. Lungkwitz documented a specific phase in the development of the property. Within a few years, Guenther would build additional rock buildings: a general store, a smokehouse, and a barn. However, the painting shows that progress had already been made. The fact that the log buildings are off in the distance suggests that they were outdated and quickly being left behind.

Though the mill was swept away long ago, Guenther's house still exists today, just off State Highway 16 (fig. 9). The house now appears much larger than the one in the

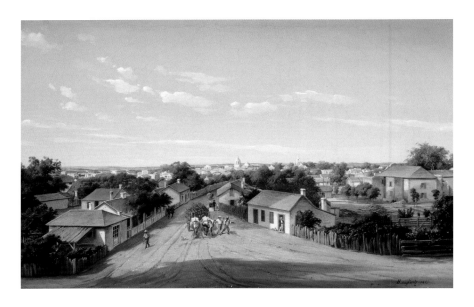

*Fig. 10. Hermann Lungkwitz, **Crockett Street Looking West, San Antonio**, 1857, oil on canvas, 12 ½ x 19 ½ in. (31.8 x 49.5 cm), Witte Museum, San Antonio.*

painting because its subsequent owner, Carl Hilker, expanded it upward in about 1886–87. Thus, the Lungkwitz painting is an important piece of material-culture evidence—the only image of the house as Carl Hilmar and Dorothea Guenther knew it.[12]

Another major Lungkwitz painting of the 1850s is *Crockett Street Looking West, San Antonio* (1857, fig. 10). At the time, Lungkwitz was still living in the Hill Country south of Fredericksburg but obviously spent time in San Antonio, which had a growing German population. In the 1850s, one-third of the residents of San Antonio were from the United States, another third from Germany, and the final third was the Hispanic population that had been there for a century or more. This painting is both a form of material-culture evidence and a painting informed by material culture.[13]

An old Sanborn Fire Insurance Map from July 1885 helps orient viewers to the scene (fig. 11). Sanborn Maps marked all buildings by materials, from stone and brick to wood and adobe, to assess their flammability. This particular Sanborn Map reveals that Lungkwitz painted Crockett Street just before it enters the Alamo Plaza, and also shows Nacogdoches Street curving in the right foreground. The principal visual remnants of Hispanic San Antonio are the church of San Fernando off in the distance, the remains of the church of San Antonio de Valero, better known as the Alamo, and the two Hispanic men who lead an ox-drawn *carreta* away from the plaza.

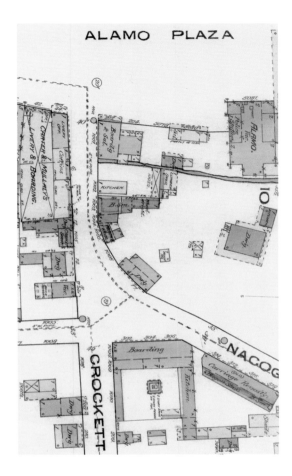

Fig. 11. Sanborn Fire Insurance Map, San Antonio, July 1885, sheet 2, Geography and Map Division, Library of Congress.

Lungkwitz's painting captures the increasing pace of change in San Antonio. Off in the distance is Saint Mary's Catholic Church, for the Irish-Texan population, and at the far right is the Alamo, which had recently been repurposed and rebuilt. The buildings of the old mission are now occupied by the United States Army, which had added a roof to the formerly roofless church so it could be used as a storage facility. The pitch of the hipped roof forced the Army to hire a local stonemason, Johann Fries, to build up the front elevation. Thus, a German stonemason created the famous curvilinear parapet of the Alamo, and the Lungkwitz painting provides rare evidence as to why it was needed and why it took the shape it did.

The painting also demonstrates that Germans were settling in the neighborhood. The house in the right foreground is the recently constructed rock house of

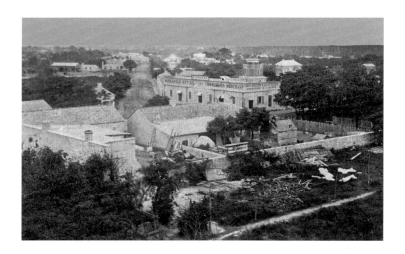

*Fig. 12. **Nacogdoches Street Looking Northeast**, c. 1868, photograph, San Antonio Conservation Society.*

Wilhelm Carl August Thielepape and his wife, Mathilde. Thielepape, who is depicted standing in the door of his house, was interested in technology, architecture, music, and art. After the Civil War, he became the first German-Texan mayor of San Antonio. His house was an excellent example of another German-Texan type: two front rooms with two front doors and a lean-to behind. The house was demolished in 1936 at the insistence of Clara Driscoll Sevier, who thought the Alamo church was the only significant building on the site. Once again, Lungkwitz documented the appearance of a historic house that would otherwise be lost.[14]

Lungkwitz chose to paint this scene from an elevated vantage point. The Sanborn Map shows a boarding house with a three-story tower behind it, and a photograph from the San Antonio Conservation Society (fig. 12) shows that the 1885 boarding-house was the 1857 store of Honoré Grenet, a wholesale, retail, and commission merchant who sold dry goods, clothing, groceries, and liquors. Lungkwitz climbed to the top of Grenet's tower to get this panoramic view of the city.[15]

Additional German rock buildings are found on the left edge of the Sanborn Map, one labeled "cabinet shop." The back side of this shop is at the far left in the photo of the Grenet store. In the painting, it appears in the middle distance. The man walking in the street, to the left of the carreta, is said to be a carpenter named Wenzel Friedrich, who in the 1880s would excel in the manufacture of furniture made from cow horns. Though his early work remains undiscovered, Friedrich was very much a part of the multicultural mix of San Antonio in the 1850s.[16]

In 1857 Lungkwitz produced important work, but he also lost his closest friend when Petri drowned in the Pedernales River near the Lungkwitz farm. This loss created a void in Lungkwitz's life, and another was created when Carl Hilmar and Dorothea Guenther moved to San Antonio in 1860. Then came the Civil War.[17]

Though some Germans accepted the right of Southerners to own slaves, many others were offended by the peculiar institution and had no desire to fight for the Confederacy. A group of German Texans trying to make it to the Mexican border in August 1862 was attacked by a band of Confederate irregulars in what became known as the Nueces massacre. Nineteen Germans were killed; another nine were wounded and then executed a few hours later. Eight more from the group were killed in October. Back in the Hill Country, there were also hangings and shootings of individuals deemed not sufficiently enthusiastic about the Confederacy.

At this lonely and scary time, Hermann Lungkwitz turned to painting the Texas landscape. Though Lungkwitz has been characterized as a "Romantic landscapist," his work up to this point was quite varied, though many had a landscape component. However, in 1862 Lungkwitz turned to pure landscape, painting both *Enchanted Rock* (fig. 13) and *Hill Country Landscape*.

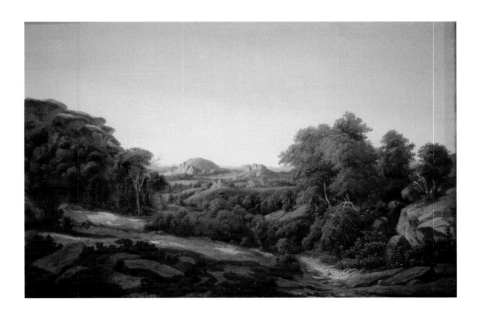

Fig. 13. Hermann Lungkwitz, **Enchanted Rock**, *1862, oil on canvas mounted on panel, 14 x 20 in. (35.6 x 50.8 cm), Witte Museum, San Antonio, 52-35 P.*

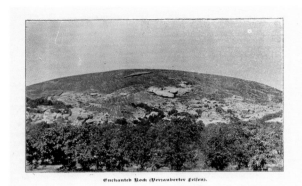

Enchanted Rock had been respected by Native Americans and commented on by Americans and Europeans long before Lungkwitz painted it. Everyone, Comanche, Anglo-American, and German, agreed that the formations surrounding the rock were downright eerie. Two German officers, who had accompanied John O. Meuesbach in 1847 when he negotiated a peace treaty with the Comanche, camped near Enchanted Rock on their way back to Fredericksburg. They later wrote, "This mass of granite, so named because of its formations which have the appearance of monstrous giants and wild beasts, reminded us of castles along the Rhine."[18]

German Texans called the rock "Verzauberter Felsen." This German phrase was used in 1896, when the newspaper publisher Robert Penniger published a book on the history of Fredericksburg, which included a photograph of the rock (fig. 14). The name would have reminded Lungkwitz, a very musical German, of the opera by Wolfgang Amadeus Mozart and Emanuel Schikaneder, *Die Zauberflöte* (*The Magic Flute*). Lungkwitz was certainly predisposed to think of the rock as enchanted.[19]

The photograph of Enchanted Rock published in 1896 was a mostly straight-on view, as one might see it approaching from Fredericksburg on Highway 965 (fig. 15). Lungkwitz chose a different perspective. He hiked northwest along Sandy Creek so that the view, looking west, would encompass some of the sunny south side as well as some of the shady north side, and include some of the formations that give the rock its magical character. Lungkwitz sought an elevated perspective from which to survey the scene—a ridge near Buzzard's Roost on the eastern border of the present State Natural Area. Though Lungkwitz loved to hike into the Hill Country and paint directly from nature, the way in which he framed the scene was informed by his training in Dresden. In Texas, he confronted scenery that was different from the scenery in Saxony, but he framed it in a way that showed his German roots.

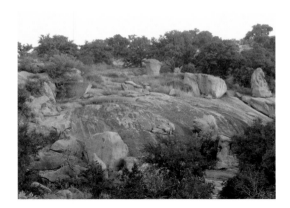

Left:
Fig. 15. **Enchanted Rock**,
September 29, 2007.

Below:
Fig. 16. Hermann Lungkwitz,
Hill Country Landscape, 1862,
oil on canvas, 18 ⅜ x 23 ⅞ in.
(46.7 x 60.6 cm), the Museum of
Fine Arts, Houston, the Bayou Bend
Collection, gift of Miss Ima Hogg,
B.67.39.

Hill Country Landscape depicts a scene on either the Guadalupe or the Pedernales (fig. 16). The acclaimed landscape architect Frederick Law Olmsted, who had visited Texas in 1854, wrote rapturously about the Guadalupe near Sisterdale, observing that the river was "quick and perfectly transparent. I have rarely seen any report of wood-nymphs more perfect than the bower of cypress branches and vines that overhang the mouth of the Sister creek. . . . You want a silent canoe to penetrate it; yet would be loath to desecrate its deep beauty." He also remarked that "the cypresses rise superbly from the very edge, like ornamental columns."[20]

umkränzenden Schwestern und deckte
mit ihren langgestreckten Aesten und
ihren ausgebreiteten, grün befiederten
Zweigen den Stein schirmend und
schattend eine uralte riesige Cypresse:
„atra cupressus."

Fig. 17. Hermann Seele, illustration for **Die Cypresse und Gesammelte Schriften** *(New Braunfels, 1936), the Texas Collection, Baylor University.*

14

Lungkwitz's *Hill Country Landscape* has a dual focus: the cypress tree and the mysterious limestone cavern. This dual focus can also be found in a short story by Hermann Seele of New Braunfels, *Die Cypresse* (fig. 17). Seele was the first schoolteacher in New Braunfels, but also a farmer, lawyer, mayor, and state representative. When *Die Cypresse* was published in 1936, it was illustrated with several woodcuts based on drawings by Seele. The short story that gives the book its title blends action-packed adventure with mystical landscapes.[21]

Seele depicted the cypress in a mountainous setting, but also emphasized the large stones at the base of the tree that conceal the entrance to a secret Indian hiding place. In the story, the intrepid hero was captured by the Native Americans, but ultimately was able to escape. Seele wrote that afterward no one could find that "mysterious entrance despite a long and careful search." Yet, he continued, by the edge of the river was "a pyramid of rock forming the tomb of the Indian tribe," beside which towered an ancient giant cypress . . . [which] sheltered and shaded the stone."[22]

Seele also discussed Hill Country landscapes in a nonfiction recounting of how the New Braunfels singing society traveled to Sisterdale for a singing festival. This journey of fifty miles each way followed the Guadalupe toward its source in the Hill Country. The arduous journey was made easier by consuming large amounts of Rhine wine. When the group arrived in Sisterdale, one of the visitors regaled the locals with the story of their journey. Along the way, they had stopped to admire two giant cypress trees growing beside the river: "We drank their health in wine, but the ancient water drinkers, whose roots have been washed by the Guadalupe River for thousands of years, only shook their heads."[23]

Seele was not the first to see the cypress as marking an enchanted landscape. As far back as ancient Greece and Rome, the cypress tree was associated with the underworld. This understanding carried into more recent times; in *Die Zauberflöte* (*The Magic Flute*), the heroine, Pamina, is abducted from a grove of cypresses. Germans in Texans surely were aware of such ideas. After all, when Olmsted visited Sisterdale in 1854, his hosts had entertained the group after dinner by singing the arias from Mozart's opera *Don Giovanni*. Lungkwitz had visited Sisterdale the previous year, in 1853, and, as a member of singing societies wherever he could find them, he must have known these singers. His *Hill Country Landscape* was framed by centuries of European tradition as well as by contemporary German and American thinking about landscape as art.[24]

The isolation and uneasiness of living on a remote farm in the Hill Country led Lungkwitz and his family to move to San Antonio in 1864. There, he saw many more people, including other German Texans, on a daily basis, and he took on art students, leading them on painting trips around the city.[25] He also teamed up with a younger

painter, Carl von Iwonski, in a photographic studio on Commerce Street just east of Main Plaza. Their studio was on the upper floor of a building occupied by the noted Texas silversmiths and jewelers Bell & Brothers. Though Lungkwitz's brother, Adolph, was a silversmith and blacksmith in Fredericksburg, Hermann was not very comfortable speaking English, so his interactions with Samuel Bell and his sons may have been limited.[26]

In 1870 Lungkwitz and his family moved again, this time to Austin, where he worked at the Texas General Land Office making photographic copies of maps. Jacob Kuechler, a survivor of the Nueces massacre who had married Marie Petri in 1856 and had farmed at Live Oak Creek, had been named commissioner of the Land Office in 1870 as part of the Reconstruction government. The Land Office building had been designed in the mid-1850s by Conrad Christophe Stremme, who had a doctorate in architecture from the University of Hannover, and who worked as the chief draughtsman in the Land Office. Stremme based his design on the German style known as *Rundbogenstil*, or round-arch style. The wing added to the north side of the building was designed specifically to house a photographic studio, though that was later removed.[27]

Initially, Lungkwitz and his family lived on the second story of the Rudolph Bertram General Merchandise Store, located at Guadalupe Street and Sixteenth Street, a neighborhood populated largely by German Texans. A photograph (fig. 18) shows family members on the gallery: Jacob Kuechler and his wife, Marie, and Guido, Eva, Alice, Martha, and Helene Lungkwitz. Hermann Lungkwitz was likely behind the camera. The Sanborn Map of 1900 reveals that the Bertram store was catty-corner to a large one-and-a-half-story rock house recently built by William and Augusta von Rosenberg, with a one-story frame porch and a single-story rock kitchen with its own porch.[28]

The photograph was apparently taken from an elevated location to the northeast of the house; Lungkwitz likely set up his camera on the upper gallery of the Bertram store. The von Rosenberg house was significant to him for two reasons. First, one of the von Rosenberg's twelve children, Lina von Rosenberg Bissell, took art lessons from Lungkwitz. Second, Lungkwitz's daughter Helene had married Ernst von Rosenberg. After the death of his wife in 1880, Hermann would rotate between the homes of his children in Austin, Galveston, and the Hill Country. While staying with Ernst and Helene, he painted the cornice in one of the rooms, presumably the parlor, in their house at 1900 San Antonio Street in Austin. A foliate cornice was a freehand alternative to increasingly popular machine-produced wallpaper. Lungkwitz's descendants preserved pieces of the cornice when the house was sold out of the family.[29]

The photograph of the von Rosenberg house (fig. 19) also captures a distant view of the new Texas Military Institute, which was the subject of a Lungkwitz painting in 1874 (fig. 20). This picturesque, castellated building, modeled on the Virginia Military

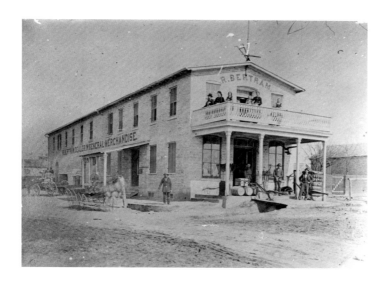

Fig. 18. Attributed to Hermann Lungkwitz, **Rudolph Bertram General Merchandise Store, West 16th Street and Guadalupe Street***, c. 1871, photograph, Austin History Center, Austin Public Library.*

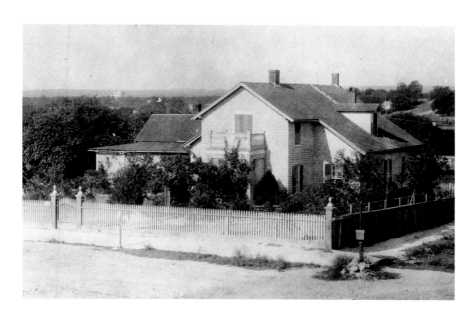

Fig. 19. Attributed to Hermann Lungkwitz, **William and Augusta von Rosenberg House***, 1504 Guadalupe, c. 1871, photograph, Austin History Center, Austin Public Library.*

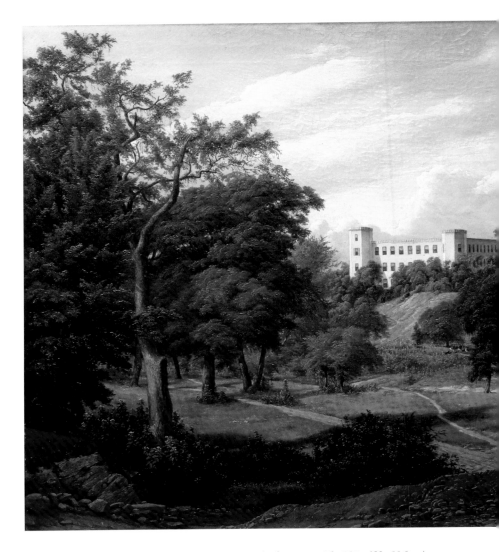

Fig. 20. Hermann Lungkwitz, *Texas Military Institute*, 1874, oil on canvas, 26 x 35 in. (66 x 88.9 cm), Texas Governor's Mansion, Austin.

Institute, still sits on a bluff overlooking Shoal Creek. Former Governor E. M. Pease wrote to his daughter Julia in September 1871 that it was altogether "a very showy building and can be seen from nearly every part of the city," and it was illustrated in Edward King's 1875 travel book, *The Great South* (fig. 21). Doubtless, Lungkwitz was

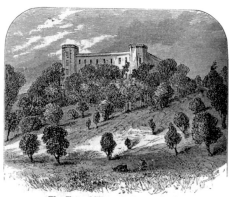

The Texas Military Institute — Austin.

Fig. 21. "The Texas Military Institute – Austin,"
in Edward King, **The Great South** (Hartford, 1875),
the Texas Collection, Baylor University, Waco, Texas.

drawn to the building's setting above the parklike precincts of Shoal Creek, but his painting is also about urbanity and progress, as it shows how much Austin was growing. Lungkwitz probably painted his view from West Avenue, the original city limit.[30]

The Lungkwitz painting *Swenson's Ruin* (1873) was remarkably different (fig. 22). Swante Magnus Swenson was a Swedish immigrant who prospered in real estate; he eventually amassed 327 acres east of Austin, where he began to build a country house in the late 1850s, possibly designed by Christophe Conrad Stremme. Work halted with the start of the Civil War. Swenson was an ardent Union man, and ultimately fled Texas, first to Mexico, then to Sweden. After the war, he returned to the United States and settled in New York City.[31]

In the Lungkwitz painting, the ruined hulk of Swenson's house stands roofless against the sky. The foreground is strewn with large boulders and one very large piece of cornice. The juxtaposition of rugged nature and highly finished, though broken, stone emphasizes the romantic, rocky site of the house, but also the process of decay that was already underway.[32]

The painting certainly has a political subtext as well, given that Swenson had refused to support the Confederate cause and had left Austin as a result. In a brief notice of an exhibition of Lungkwitz's paintings in 1878, the *Daily Democratic Statesman* mentioned that "the dilapidated Swenson building" was one of the canvases that was "greatly admired." The use of the term "dilapidated" is telling, as it both questions the value of a ruined building as subject matter and seems to imply that the owner had failed to take care of the structure. There was no acknowledgment that the owner had felt forced to flee the state.[33]

Lungkwitz continued to explore Hill Country landscapes even into his seventies. In *West Cave on the Pedernales* (1883, fig. 23), the texture of the rock creates a counterpoint to the foliage of the trees. Lungkwitz found a wildness here in spite of the fashionably dressed tourists in the middle of the composition. In the foreground, he painted the stump of a cypress tree, which McGuire interpreted as suggesting "the advance of man into the pristine wilderness." However, this tree, hundreds of years old at the time, was not actually cut, and can still be seen at West Cave Nature Preserve outside of Austin. Perhaps Lungkwitz reduced the tree to a stump so as not to interfere with the horizontality of his composition. Like Caspar David Friedrich and Hermann Seele, Lungkwitz believed that landscapes embodied spirits deep beneath the surface.[34]

Hermann Lungkwitz died in 1891 at age seventy-seven. He was buried in the family plot in Oakwood Cemetery in Austin, next to Elise. In his early years, Lungkwitz had depicted German cemeteries with hand-carved monuments, but he and his family rest beneath machine-carved gray granite markers, a type of marker that had not been available when the family came to Texas forty years earlier. Even in death, the family reflected changes in material culture.[35]

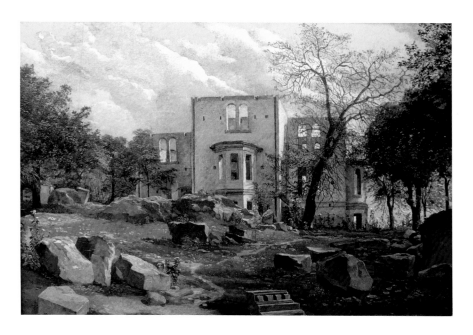

Fig. 22. Hermann Lungkwitz, **Swenson's Ruin, Austin***, 1873, oil on academy board, 10 ⅜ x 14 ⅜ in. (26.4 x 36.5 cm), collection of Bill and Eloise Blakeley.*

Lungkwitz both documented material culture and created it. He came to Texas as a former resident of Dresden, a major European cultural center, and as a highly trained painter. These qualities allowed him to see the contrasts between European civilization and the Texas frontier, and to see the contrasts between majestic Alpine mountains and enchanted Texas hills, between the Rhine River lined with castles and the Guadalupe and Pedernales Rivers lined with cypress trees. His urbanity seems to have made him sensitive to the many small steps that Texans were taking toward a more civilized existence. Texas material culture would not be as well documented if not for Hermann Lungkwitz, and yet his art would not be as complicated or intriguing without Texas's changing material culture.

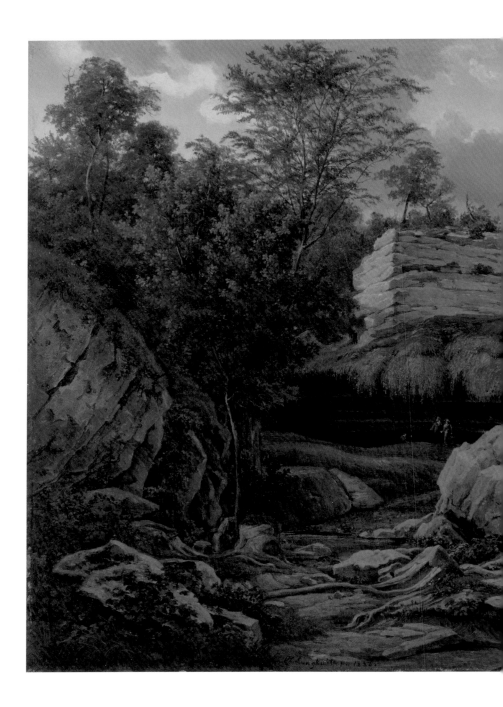

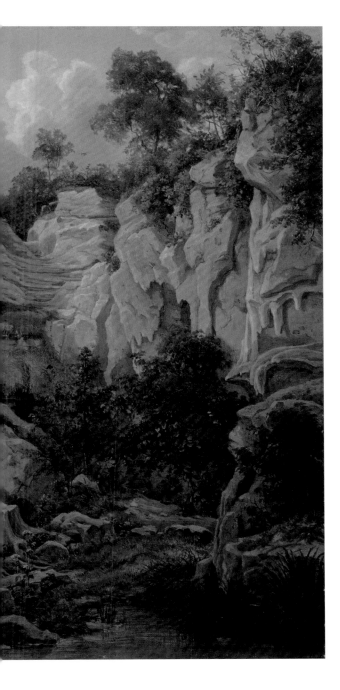

Fig. 23. Hermann Lungkwitz,
West Cave on the Pedernales, *1883, oil on canvas, 13 ¾ x 23 ⅞ in. (34.9 x 60.6 cm), William J. Hill Collection.*

Notes

1 Margaretta M. Lovell, "American Material Culture: Artists, Artisans, Scholars, and a World of Things," in *American Material Culture and the Texas Experience: The David B. Warren Symposium, Volume 1* (Houston: The Museum of Fine Arts, Houston, 2009), 45–65.

2 Pauline A. Pinckney, *Painting in Texas: The Nineteenth Century* (Austin: University of Texas Press for the Amon Carter Museum of Western Art, 1967), 99–118; William W. Newcomb, Jr., with Mary S. Carnahan, *German Artist on the Texas Frontier: Friedrich Richard Petri* (Austin: University of Texas Press with the Texas Memorial Museum, 1978), 3–27; James Patrick McGuire, *Hermann Lungkwitz: Romantic Landscapist on the Texas Frontier* (Austin: University of Texas Press for the University of Texas Institute of Texan Cultures at San Antonio, 1983), 1–8; Cecilia Steinfeldt, *Art for History's Sake: The Texas Collection of the Witte Museum* (Austin: Texas State Historical Association, 1993); Ron Tyler, "The Arts in Early Texas: A Cultural Crossroads," in *American Material Culture and the Texas Experience: Itinerant and Immigrant Artists and Artisans in 19th-Century Texas: The David B. Warren Symposium, Volume 4* (Houston: The Museum of Fine Arts, Houston, 2014), 1–31, esp. 22–25.

3 McGuire, *Hermann Lungkwitz*, 1–8; Newcomb, *German Artist on the Texas Frontier*, 5–13.

4 William Vaughan, *German Romantic Painting* (New Haven, CT: Yale University Press, 1980), 65–116; Helmut Börsch-Supan, *Caspar David Friedrich* (New York: George Braziller, 1974); Joseph Leo Koerner, *Caspar David Friedrich and the Subject of Landscape* (New Haven, CT: Yale University Press, 1990).

5 Vaughan, *German Romantic Painting*, 127, 139–42.

6 Ibid., 207–13, 227.

7 For Lungkwitz's *Grave of Louis Pfeiffer*, see McGuire, *Hermann Lungkwitz*, 90, 168. For the Friedrich version, see Börsch-Supan, *Caspar David Friedrich*, 144–45; Koerner, *Caspar David Friedrich and the Subject of Landscape*, 200. For the Richter version, see Vaughan, *German Romantic Painting*, 208, 212.

8 Newcomb, *German Artist on the Texas Frontier*, 164.

9 Ibid., 111.

10 McGuire, *Hermann Lungkwitz*, 15, 57.

11 Kenneth Hafertepe, *The Material Culture of German Texans* (College Station: Texas A&M University Press, 2016), 126–30. On Guenther, see *An Immigrant Miller Picks Texas: The Letters of Carl Hilmar Guenther*, ed. Regina Beckmann Hurst and Walter D. Kamphoefner (San Antonio: Maverick Publishing Co., 2001).

12 Kenneth Hafertepe, *A Guide to the Historic Buildings of Fredericksburg and Gillespie County* (College Station: Texas A&M University Press, 2015), 257–61.

13 McGuire, *Hermann Lungkwitz*, 15, 182.

14 Hafertepe, *The Material Culture of German Texans*, 140–41.

15 Rudolph Menger, a former student of Lungkwitz, recalled that he used the Grenet tower to paint Crockett Street. McGuire, *Hermann Lungkwitz*, 31.

16 Ibid., 187.

17 Ibid., 19; Hurst and Kamphoefner, *An Immigrant Miller Picks Texas*, ix–x, 77–82.

18 McGuire, *Hermann Lungkwitz*, 23–24, 186; Robert Penniger, *Fest-Ausgabe um 50-jährigen Jubiläum der Gründung der Stadt Friedrichsburg* (Fredericksburg, TX: Robert Penniger, 1896), translated as *Festival Edition for the Fiftieth Anniversary Jubilee of the Founding of the City of Fredericksburg*, trans. Charles L. Wisseman, Sr. (Fredericksburg, TX: Fredericksburg Publishing Co., 1971), 42.

19 Penniger, *Festival Edition*, 98.

20 Frederick Law Olmsted, *A Journey through Texas, or a Saddle-Trip on the Southwestern Frontier* (New York: Dix, Edwards and Co., 1857), reprinted (Austin: University of Texas Press, 1978), 193–94.

21 Hermann Seele, *Die Cypresse und Gesammelte Schriften* (New Braunfels, TX: Neu-Braunfelser Zeitung, 1936), *The Cypress and Other Writings of a German Pioneer in Texas*, trans. Edward C. Breitenkamp (Austin: University of Texas Press, 1979).

22 Seele, *The Cypress and Other Writings*, 161–86.

23 Ibid., 109–19, esp. 114–15.

24 Olmsted, *A Journey through Texas*, 198.

25 McGuire, *Hermann Lungkwitz*, 27–29.

26 Ibid., 29–30.

27 McGuire, *Hermann Lungkwitz*, 18, 22, 31–35; Hafertepe, *The Material Culture of German Texans*, 324–32.

28 Hafertepe, *The Material Culture of German Texans*, 155–56.

29 One fragment from the von Rosenberg house is in the collection of the Austin History Center, the Austin Public Library; another remains in the possession of the family.

30 McGuire, *Hermann Lungkwitz*, 36; E. M. Pease to Julia Pease, January 14, 1872, Niles-Pease-Graham Collection, Austin History Center, as quoted in Kenneth Hafertepe, *Abner Cook: Master Builder on the Texas Frontier* (Austin: Texas State Historical Association, 1992), 156; Edward King, *The Great South* (Hartford, CT: American Publishing Company, 1875), 128.

31 Handbook of Texas Online, Richard Moore, "Swenson, Swante Magnus," accessed April 26, 2017, http://www.tshaonline.org/handbook/online/articles/fsw14.

32 McGuire, *Hermann Lungkwitz*, 58.

33 Ibid., 37.

34 Ibid., 58 (quotation), 59.

35 On the transition from limestone and marble to granite grave markers in Texas, see Hafertepe, *The Material Culture of German Texans*, 427–32.

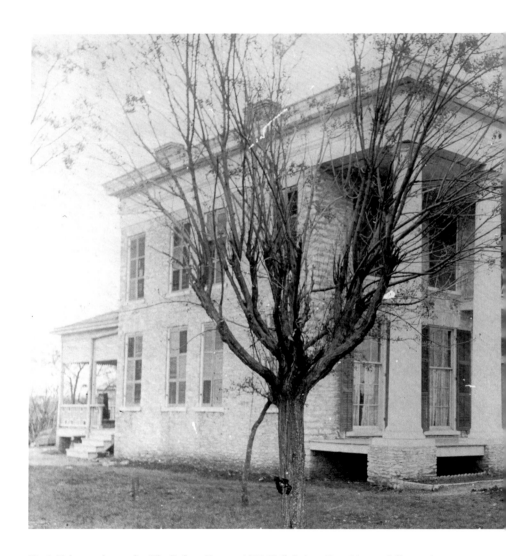

Fig. 1. Unknown photographer, **The Cochran House**, c. 1905, Neill-Cochran House Museum Collection, Austin.

On the Edge:
The Neill-Cochran House, the Late Antebellum Era, and the Changing Face of Texas

Rowena Houghton Dasch

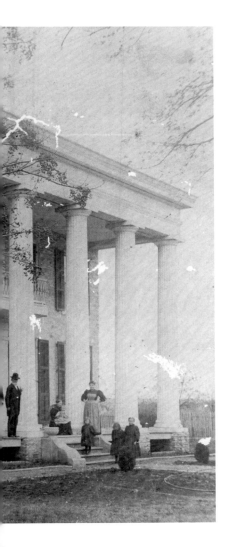

The history of the Neill-Cochran House Museum (fig. 1), or "Hill House" as it originally was called after its first owners, presents one version of an origin story for Austin. The 1856 Greek Revival–style home in Austin, Texas, designed by master builder Abner Cook, has been both a witness to and an artifact of 160 years of dramatic change. Its history draws in multiple populations, from slaves, to free African Americans, to immigrant servants and boarders, to the Anglo families who owned and lived in the main house over its hundred-plus years of occupancy.

This story is the chronicle of a small town groping toward subsistence and then prosperity, all within an era of rapid and dislocating change. It begins within a paradigm that is unrecognizable to contemporary Austin residents and visitors. In 2015 the U.S. Census estimated that the population of Austin was more than 930,000. It is hard to conceive, therefore, that the city did not cross the 100,000 threshold until after World War II and that fewer than 3,500 people lived there at the outbreak of the Civil War.[1]

The Hill House originally sat on seventeen acres well outside the boundaries of the city of Austin. Indeed, as late as the early 1870s, the property simply was listed as "suburban" and had no street address. The two surviving structures (the historic main house and the dependency)

are original to the property, and San Gabriel and Twenty-Third Streets are today defined by the original access points and carriage routes on the land.

The historical site as an artifact and the people who interacted with it speak to life in central Texas, to what became Austin, and to the important role that master builder Abner Cook played within that growing community. The main house is a magnificent example of the Greek Revival style, adapted to local natural resources and to a limited budget. It features an unornamented entablature over fluted wooden Doric columns, a cantilevered balcony the width of the upstairs hall, and a four-square symmetrical plan with a central hall.

The dependency structure is the only secondary building that survives at the site from the 1850s. It is also two stories and built of limestone rubble, and has an exterior staircase common to buildings of the type in nineteenth-century Texas. The property also originally had a freestanding kitchen, an outhouse, and a barn and carriage house. It is not clear that the acreage was ever farmed, though in all likelihood that was the Hills' original intent.

Abner Cook and the Growth of Austin

Abner Cook was born in 1814, and was reared in Salisbury, North Carolina, where he was apprenticed to a master builder or carpenter.[2] In 1839 Cook made the decision many other young men were making at that time: to gamble his future on the new nation of Texas. Cook, then twenty-five years old, arrived at the port of Galveston in the spring of that year. By August he had made his way to the fledgling community of Austin. Outside of one commission that took him to East Texas, Cook never left Austin again.

The Texas Legislature had spent much of 1838 debating options for a new national capital. The legislators were unhappy with Houston and complained that the recently erected buildings were poor in quality, the roads almost nonexistent, and the character of the residents unsavory. President Mirabeau B. Lamar advocated moving the capital to the western frontier for strategic reasons. He wanted to disrupt the movements of Native American groups and of Mexican bandits, who crossed the Colorado River in the area of what is now Austin to gain access to East Texas. Ultimately, with Lamar's support, the legislature selected a site on the Colorado River in Bastrop County, on the western end of the then-surveyed land of Texas.

When the legislature announced the chosen location, one writer described the site as "on the frontier . . . in the country of the enemies of the white man," before enthusing that the country was "beautiful" and that the new capital city would advance "the prosperity of Texas."[3] At the time the legislature selected the location of the new capital, the extent of settlement in the area amounted to four families on the banks of the

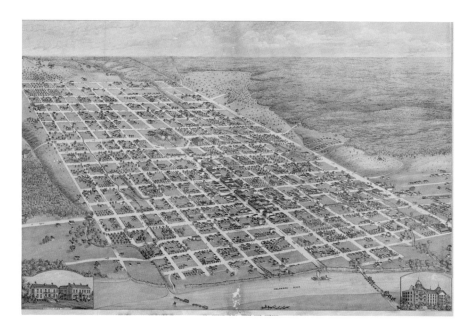

*Fig. 2. Augustus Koch, published by J. J. Stoner, Madison, Wisconsin, **Bird's Eye View of the City of Austin Travis County Texas 1873**, 1873, lithograph with hand coloring, 19 ¾ x 28 ⅛ in. (50 x 71.4 cm), Center for American History, the University of Texas at Austin.*

Colorado River and a stockade of animals. When the government convened for the first time in Austin, the town was quite literally the end of the road.

Austin was a blank slate—there were no existing buildings to work around—and the gridding of the city's core reflects that fact. Austin hugged the central thoroughfares of Congress Avenue and Pecan Street in the early years, only slowly expanding away from this central axis. Augustus Koch's *Bird's Eye View of the City of Austin* (1873, fig. 2) shows the irregular expansion of homes away from the center of town, but does not depict the area around the Hill House, at that point almost twenty years old.

Abner Cook scrambled to build a career for himself during these early years, and his career grew with the city. The earliest buildings were intended to be temporary, and their construction was consequently rude. Cook participated in the building of numerous log structures, including his own home and Austin's first Presbyterian church. Cook initially formed a company with Heman Ward, a builder and carpenter, and worked both with Ward and on his own. He also participated in a lumber venture in nearby Bastrop and, by the early 1850s, was the sole proprietor of the two brick kilns operational in Austin.

Construction in Austin occurred in fits and starts. In 1842 the national government abandoned Austin after the Mexican army invaded Texas and captured San Antonio not once, but twice. The government returned in 1845, but Texas almost immediately became embroiled in the Mexican-American War, and the viability of Austin as a permanent capital city remained questionable.

Austin was more than a decade old when the political climate settled, and it seemed likely to remain the capital, now of the state rather than of the nation of Texas. Cook was perfectly positioned to take advantage of the funding that suddenly began to flow as the government and private citizens alike replaced temporary wooden structures with finer, more permanent buildings. The first stone Capitol building, the General Land Office, the Governor's Mansion, and the Hill House all date to this period. With the exception of the General Land Office, Abner Cook was involved in all of these projects.

The period of feverish activity in the 1850s stemmed from the stability, peace, and economic strength that attended the end of the Mexican-American War and a boom in cotton prices. New development proceeded at a dramatic pace. After a trip through Texas in 1855, the landscape architect and social critic Frederick Law Olmsted wrote of the city, "Austin has a fine situation upon the left bank of the Colorado . . . It reminds one somewhat of Washington; Washington en petit, seen through a reversed glass." However, much work remained to be done. Olmsted described the view from the Capitol grounds: "a broad avenue stretches to the river, lined by the principal buildings and stores. These are of various materials and styles, from quarried stone to the logs of the first settlers. Off the avenue, are scatered [sic] cottages and one or two pretty dwellings. They are altogether smaller in number and meaner in appearance than a stranger would anticipate."[4]

Cook was hard at work helping to increase the number of "pretty dwellings" in Austin. Between 1849 and 1860, he completed the design and construction of thirteen Greek Revival homes, seven of which are extant. One imagines that, had the Civil War not intervened, Cook would have continued to construct homes in this style for another decade. However, slavery was the backbone of the success of Texas in the 1850s, and war was looming. As a result, the no-longer-extant Thomas H. Duval House (1859–60) was Cook's final project before war broke out and his final home in the Greek Revival style.

Architecture and Layout

The Hill House was a product of its historical moment for its builder, its style, its layout, and its materials. When Washington and Mary Hill began to work with Abner Cook in 1855, he was the preeminent residential master builder in Austin. Aside from the French Legation (1841), no well-appointed antebellum residence has survived in Austin besides the series of structures built by Cook. His popularity within Austin is not surprising.

Cook designed homes in the prevailing style with close attention to finish details. Though Greek Revival may have been on the wane in other parts of the United States by the time Cook took it up, its popularity moved westward and onward in date with the Anglo-American population. It is therefore unsurprising that in the 1850s, two decades after the style's zenith further east, the city of Austin embraced the Greek Revival as modern. Americans looked to the high style of their youth as they traveled west from the colonial period through the nineteenth century.

The Hill House fits well within this brief era of heady optimism for the grand statement the architecture of the main house makes and for the Hills' dramatically optimistic plans. The main house is an excellent example of the Greek Revival style in general layout, scale, and wooden millwork. However, changes to the scope of work also suggest the tenuousness of the economic boom and the difficult days that lay ahead during the Civil War. A series of financial documents, including loans and the sale of slaves, record the Hills' increasing recognition that they had embarked on too large a project. Their dwindling finances had numerous consequences for the design and construction of the house, necessitating compromises in the choice of materials and in the floor plan, and the family never moved in.[5] The budget, antebellum date, and natural resources available in the Austin area resulted in a unique structure: a grand Greek Revival mansion constructed of limestone rubble, Bastrop pine, and cedar.

Cook joined numerous builders around the country in employing a four-square or central plan for the Hill House as well as for the Texas Governor's Mansion. The two projects overlapped in time frame, and Cook may have returned to the layout for convenience, or to accommodate the Hills' smaller budget; however, it also is possible that this common layout simply paired well with the six-column colonnade that Cook favored. Cook also relied heavily on design books, in particular Minard Lafever's *Beauties of Modern Architecture* (1833). Manuals by Lafever and Asher Benjamin provided regional builders with aesthetic inspiration for their finish details as well as technical specifications. Cook incorporated a shouldered architrave with a slight pediment and battered sides at the Hill House and Governor's Mansion that he drew directly from plate 1 of *The Beauties of Modern Architecture* (figs. 3–6).

Other homes around the country featured even clearer references to Lafever's work. One such example, Milford, the John L. Manning house in South Carolina (1839–41), follows Lafever scrupulously. Nathaniel F. Potter, a brickmason from Rhode Island, designed the home and drew finish details directly from *The Beauties of Modern Architecture*. Whereas Cook looked to Lafever for overall design, Potter faithfully incorporated the details of palmettos and scrollwork in his decorative trim, as evidenced in a comparison between a first-floor parlor doorway and Lafever's plate 19 (figs. 7, 8).[6]

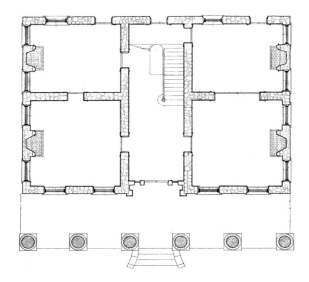

Left, top to bottom:
Fig. 3. **Floor Plan, Hill House**, Historic American Buildings Survey, HABS TEX, 227-AUST, 21-1, Library of Congress Prints and Photographs Division, Washington, D.C.

Fig. 4. **Floor Plan, Governor's Mansion, Austin, Texas**, Historic American Buildings Survey, HABS TEX, 226-AUST, 3-1, Library of Congress Prints and Photographs Division, Washington, D.C.

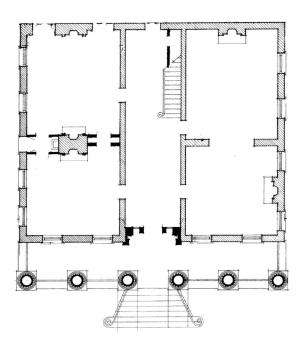

Opposite page, top, left to right:
Fig. 5. **Front Hall, Neill-Cochran House Museum**, Neill-Cochran House Museum Collection, Austin.

Fig. 6. Plate 1 in Minard Lafever's **The Beauties of Modern Architecture**, 3rd ed. (New York: D. Appleton & Co., 1839).

Opposite page, bottom, left to right:
Fig. 7. **Parlor Door, John L. Manning House, Sumter County, South Carolina**, Historic American Buildings Survey, HABS SC, 43-PINWO.V, 1-18, Library of Congress Prints and Photographs Division, Washington, D.C.

Fig. 8. Plate 19 in Minard Lafever's **The Beauties of Modern Architecture**, 3rd ed. (New York: D. Appleton & Co., 1839).

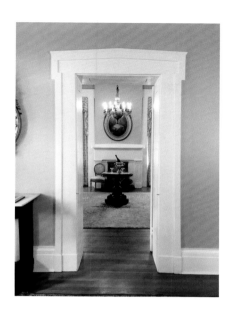

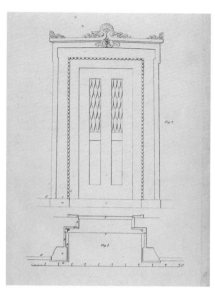

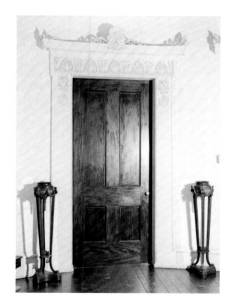

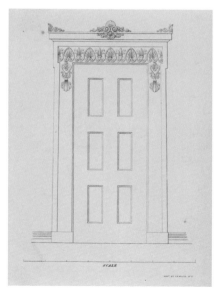

The most dramatic feature of the Hill House's facade was the direct result of budget constraints: the decision to build with limestone rubble. Limestone rubble was a common building material during the 1850s through the end of the nineteenth century. However, typically builders used it for commercial projects and for less-expensive residential structures. Many downtown commercial buildings built of limestone rubble had brick facades by the 1870s.[7] Sheet 2 of the 1877 Sanborn Fire Map documents that, at that time, brick facades fronted seven contiguous limestone-rubble buildings on the east side of Congress Avenue between Ninth and Tenth Streets (fig. 9). Similar brick facings for masonry structures can be found throughout the 1877 Sanborn Fire Map sheets.[8] One of the Hill House's nearest neighbors, the 1869 Fontaine Building, is also of limestone rubble. The original owner built the commercial-residential structure on a small budget in the Wheatville freedman neighborhood, likely with the help of his neighbors, and the masonry is even more irregular than that of the Hill House. The Hill House stands out as a fine home built of simple materials.

The Hills further reduced the overall cost of their project by quarrying the necessary stone on their own property, almost certainly employing slave labor. An inventory of costs related to the construction of the 1855 Travis County courthouse recorded that, in the same year that Cook was planning the Hill House, Travis County paid $1,602 for 356 perches (just over 217 cubic yards) of "rough stone work."[9] The Hill House required significantly more stone, approximately 550 perches.[10] Travis County tax records show an increase in property value of the Hill House from $900 to $8,000 between 1856 and 1857, suggesting that the total construction cost was just over $7,000.[11] If the Hills had purchased 550 perches of rough stone, the cost for the stone alone would have been $2,475. This would have represented a third of the total cost.

The use of limestone rubble had major consequences for the overall design of the Hill House. Comparison of the Governor's Mansion and Hill House floor plans shows design divergences necessitated by the different building materials, most obviously in the location of fireplaces and in the connecting doors in the north-side parlors. In the Governor's Mansion, which is built of brick, one chimney serves two fireplaces in the middle of the interior wall between the study and dining room, a design that the Hill House, with its smaller footprint and thick limestone walls, would not support. Those limestone walls created additional difficulties by rendering pocket doors, standard features of a double-parlor design, impossible. The Hill House instead has massive French panel doors that cannot be used without moving all of the furnishings in the back parlor.

It is almost certain that the Hills originally intended to conceal the limestone rubble by plastering and scoring the exterior in imitation of dressed limestone. During the 1850s, it was unusual at best to construct a two-story Greek Revival residence with a grand entablature and six-column colonnade. Pairing that high style with a rubble

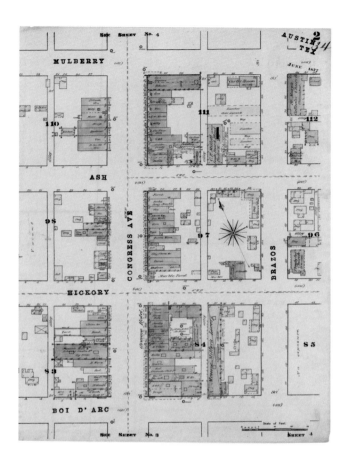

*Fig. 9. Sanborn Map Company, **Austin, Texas, June 1877**, sheet 2 (detail), Collection University of Texas at Austin.*

limestone facade makes little sense aesthetically. The General Land Office, a well-documented project completed in the same year as the Hill House, is a limestone-rubble building with scored plaster. Designer Christoph Conrad Stremme's original 1854 elevation drawing shows that the effect of dressed stone was intended from the earliest phase of design. Had the Hills completed their project, their home would have featured a similar plaster exterior. Of all the compromises to the design and construction, the facade would have been the most immediately obvious to antebellum Austinites.

Cook worked on another project in 1856 that also appears to have anticipated a scored plaster facade: the Reuben and Mary Runner House, Westhill. With an estimated cost of $4,600, Westhill was less expensive to construct than the Hill House. It also had a compromised setting, built into a hill with a bottom half-story. To further complicate the construction, the bottom floor is limestone rubble while the second floor is brick.

Reuben and Mary Runner left few footprints in Austin, arriving after the 1850 U.S. Census and leaving before 1860. Their home, however, fits in to the same category as the Hill House—a project built on grand, but ultimately unrealized, expectations.

Beyond the material choices, errors in the Hill House's finish details suggest strongly that Cook's engagement in the work ended with the floor plans. Cook was a master of proportion and of tapering millwork. Though some elements of the design and of the finish treatments show strong evidence of Cook's fingerprints, numerous design errors are inconsistent with Cook's work elsewhere in the Hill House and in his other projects. These errors suggest that the scope of the main building was reduced after the original plans were approved but before construction actually began.

At the front door and in the front hallway, the entryway and the doorways to three of the four rooms feature shouldered-architrave tapering millwork. The windows in the front rooms have the same shouldered-architrave tapering millwork, though without the slight pediment. The millwork does not copy the organic flourishes that mark Minard Lafever's patterns in *The Beauties of Modern Architecture*, but in proportionality and refinement it mirrors the designs.

The finish details, however, break down at the back of the building. The windows in the back parlor and dining room barely fit into their openings, and the framing consists of a single board about an inch deep to either side. The stairwell also cuts across the back door to this room. The construction team attempted to include the shouldered architrave (the bottom left corner of the architrave is just visible to the left of the door), but it has lost its elegance and is simply vestigial. A similar fate met the central back door to the home. It lost the top of its architrave to the staircase, which wraps around at the back wall and engages the millwork at the back door.

The Hill House floor plan speaks clearly to changes in scope. The front rooms are larger than the back rooms. By comparison, the back rooms of the Governor's Mansion are deeper than the front. Based on the way in which the Hill House staircase engages the back entrance to the parlors, and the main back door to the house, approximately four feet were cut off the back of the design (figs. 10, 11). This decision must have been made prior to breaking ground, because no evidence has been found of a secondary foundation behind the structure. These errors together render it unlikely that Cook remained involved in the project after approval of the original plans.

While some elements of the building process are easily visible, others remain in hiding inside the walls. Several years ago, the Neill-Cochran House Museum undertook a major structural restoration aimed at shoring up the foundation and the lintels above all of the windows and passageways in the house. When the walls above the windows were opened up, cedar lintels were found. Cedar is an extremely hardy wood, strong and

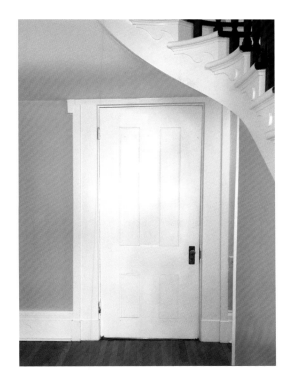

Left:
Fig. 10. **Back Door, Neill-Cochran House Museum***, Neill-Cochran House Museum Collection, Austin.*

Below:
Fig. 11. **Back Hall or Parlor/Dining Room Window, Neill-Cochran House Museum***, Neill-Cochran House Museum Collection, Austin.*

bug-resistant, and the lintels bore their loads for 150 years. However, what is fascinating about their use here is that they were installed in the walls with so little shaping. Indeed, as is apparent in this exposed lintel, only one side was planed, and the hairy bark of the cedar remains visible. It is the final piece in the puzzle of understanding how budget impacts construction.

The Impact of Slavery on the Design of the Hill House

The two-story dependency that stands just to the northwest of the main house firmly situates the Hill House at the end of the antebellum period (fig. 12), as do the multiple exit points at the rear of the house. In short, the history of the house and its construction cannot be understood fully without considering its status as an antebellum home built in a slave state and for a slave-owning family.

The dependency, like the main house, is built of limestone rubble. However, the structure bespeaks the lower status of its occupants in myriad ways: an exterior staircase, smaller and fewer windows, lower-quality wooden flooring upstairs and a dirt floor downstairs, no plastering of the interior walls, and thinner walls that leave the cedar lintels above the doors and windows exposed on both the interior and exterior of the building.[12] Nonetheless, the limestone rubble walls have preserved the structure as the only slave quarters extant in the Austin city center.

The dependency and the freestanding kitchen structures allowed slaves to live and work outside of the main house. The design of the house also appears to have envisioned the need for household staff to enter and leave the public entertaining spaces frequently and discreetly; both back rooms had original exterior doors to the back of the property. Cook occasionally made use of such exterior doors. The Governor's Mansion, with the same floor plan, did not include exterior doors in the back rooms, though Woodlawn (the Shaw-Pease-Shivers House, 1854) did. The additional doors provided slaves and, later, servants with direct access points for service in those rooms.

Five years after the Hill House was built, the American painter Eastman Johnson first exhibited the powerful genre scene *Negro Life at the South* (fig. 13). This painting captures the back of the "yard" of a wealthy Washington, D.C., family just prior to the Civil War. Washington, D.C., was a decidedly urban setting, unlike Austin. However, both communities shared a division of spaces between the "big house" at the front of the property and the dependent outbuildings at the back. As John Davis has argued, Johnson's painting walked a careful line that allowed both slavery supporters and opponents to see their viewpoints conveyed through the narrative scene.[13] For our purposes, the significance of the image lies in the community created by the outbuildings and the need for those spaces within the paradigm of the slave system. The Hill House incorporated a

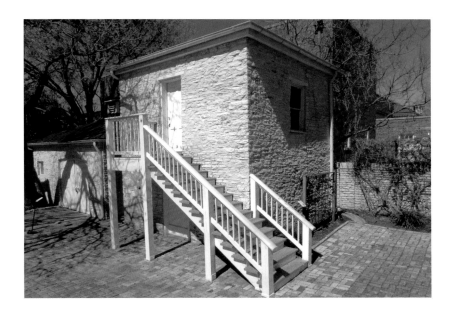

Fig. 12. Dependency, Neill-Cochran House Museum, Neill-Cochran House Museum Collection, Austin.

similar system of outbuildings, with the extant dependency within twenty feet of both the back of the main house and the detached kitchen.

The Hill House, situated on an out-lot away from the center of Austin, would have required numerous outbuildings, including spaces intended for slave housing. Interestingly, the Civil War did not disrupt the construction of outbuilding housing for domestic staff in Austin. The 1889 Austin Sanborn Fire Map documents numerous secondary structures affiliated with dwellings (fig. 14). Many of these buildings were constructed after the Civil War. They, as well as U.S. Census records, document that many domestic servants continued to live on their employers' property after the war.

Census data for 1880 and 1900 show that servants continued to live on site at the Hill House well after the end of the Civil War. Family life during the Neill and Cochran eras, in general, looked very different from the later twentieth- and twenty-first-century prioritization of the nuclear family. The 1880 U.S. Census documents Andrew and Jennie Neill, their two children, Andrew's first wife's mother, and Jennie's sister as living on the site. A boarder from Sweden, listed as twenty-five years old and a merchant, and several servants (one from Germany, and three African Americans, two of whom were married to each other) made up the rest of the household.[14] How did these eleven people share the home? One imagines that the servants lived in the dependency and possibly

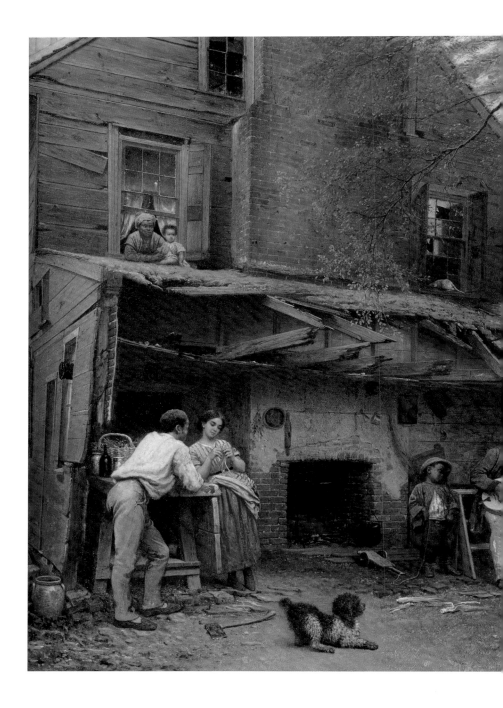

Fig. 13. Eastman Johnson, **Negro Life at the South**, 1859, oil on linen, 51 x 61 in. (129.5 x 154.9 cm), the New-York Historical Society, the Robert L. Stuart Collection, gift of his widow Mrs. Mary Stuart.

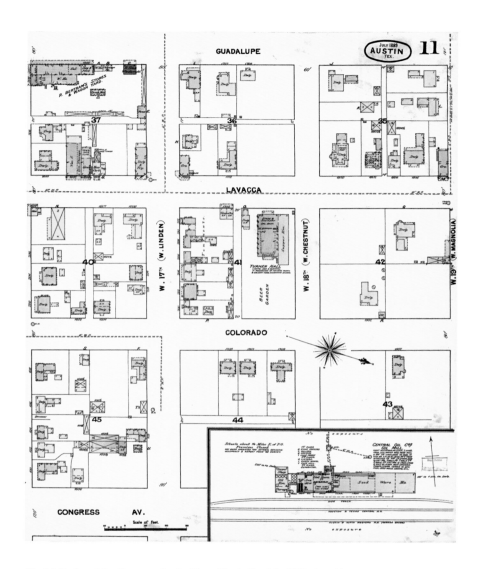

Fig. 14. Sanborn Map Company, **Austin, Texas, Travis Co., July 1889**, *sheet 11,*
Collection University of Texas at Austin.

42

in other no-longer-extant buildings on the property. Perhaps the same is true of the boarder, C. A. Anderson. Even if so, the quarters were tight.

In 1900 the U.S. Census reported that eleven people still lived at 2310 San Gabriel Street, though the makeup of the household had shifted. Thomas and Bessie Cochran, who had purchased the house from the Neills in 1895, had five children. Bessie Cochran's parents also lived with the family, as did one boarder (William H. Slay, age twenty-four, listed as "at school") and one servant (Amanda Anderson, age twenty-seven, born in Sweden and listed as the "cook").[15] Indeed, across the South well into the twentieth century, domestic servants continued to live on site, often in freestanding structures.

The shift in the makeup of the household did not impact the residents of the main house substantially, for servants would not have lived in the home with the family. The reduction in the on-site staff size seems to relate instead to a change in the way in which servants interacted with the family. By living off-site, they had greater independence, and their engagement with the property was that merely of a job. At the same time, the Cochrans added on to the rear of the main house, attaching a kitchen to the home as well as plumbing and screened-in porches. Though the Cochrans continued to employ a live-in "cook," they had a smaller domestic staff and therefore were more involved in the day-to-day operations of the home; as a result, the freestanding kitchen became an inconvenience.

Coda

The site known today as the Neill-Cochran House Museum survives largely intact, though with exceptions. At about three-fourths of an acre, it is much smaller than the original property, which was seventeen acres. Also, it has been subject to a series of renovations and additions. However, the main building has changed surprisingly little, despite weathering numerous shifts in ownership and occupancy, perhaps thanks to its eighteen-inch-thick stone walls.

After the Hills sold the house, its first residents were the students and teachers of the Texas State School for the Blind. The federal army used the main building as a hospital in the year following the Civil War, and then its owners rented it to a series of short-term occupants for the next decade. The Hill House was twenty years old before it saw its first stable family, that of Andrew and Jennie Neill.

The only major changes to the interior of the 1856 main house date to the Cochran era. In 1916 the Cochran family embarked on an aesthetic update.[16] They removed wall-to-wall carpeting, which had gone out of fashion, and covered the original pine flooring on the ground floor with oak. At the same time, they replaced the front doors with doors with large beveled-glass panels, and put elaborate beveled-glass windows around the

doors, replacing simpler rectangular side lights and over lights. The original flooring, double doors, and window lights remained on the second floor, leaving the modern visitor with the impression that the upstairs is a nineteenth-century space while the downstairs is early twentieth century in style.

Nevertheless, the historic limestone-rubble main house and dependency have weathered the ages and transitions in such a way that one can appreciate how the property was used by the different people and classes who engaged with it. Due to the intransigent construction, it would be difficult to live in the main house today, and impossible without the additions. Who would be willing to go to the "necessary" out back, or cook in a detached kitchen? Who could live with a single small closet under the stairs? What about laundry? A butler's pantry? Yet these impossibilities are the connection point to another time, and to another cultural reality.

The Neill-Cochran House was built in the middle of the 1850s, the last decade of the antebellum era, by a family on the move. It is true that their goals were untenable, but their aspirations speak to a way of life that quickly passed away. The artifact that remains teaches us about that way of life, about how the owners and servants saw their roles and their positions within the physical spaces that were constructed, and about the way in which economic reality intrudes on overarching vision.

Notes

1 The 1860 U.S. Census records a total population of 3,494, of whom 2,505 were white, twelve were free colored, and 977 were enslaved. In Travis County (which included the Neill-Cochran House at that time, as the city of Austin had not incorporated that land), the census recorded 4,931 white, thirteen free colored, and 3,136 enslaved for a total of 8,080. Joseph C. G. Kennedy, *Population of the United States in 1860; Compiled from the Original Returns of the Eighth Census, under the Direction of the Secretary of the Interior* (Washington, D.C.: Government Printing Office, 1864), 476–81.

2 Kenneth Hafertepe notes that Abner Cook appears among the William Cook family in the 1820 federal census, but does not in 1830, supporting the likelihood that his family apprenticed him to a builder or carpenter at some point during that decade. Kenneth Hafertepe, *Abner Cook: Master Builder on the Texas Frontier* (Austin: Texas State Historical Association, 1992), 5.

3 Anonymous writer, Houston, Texas, January 19, 1839. Reprinted by the *Texas Monument*, October 16, 1850, from the *Alabama Observer*. Cited in Ernest William Winkler, "The Seat of Government of Texas," *The Quarterly of the Texas State Historical Association* 10, no. 3 (January 1907): 216.

4 Olmstead finished with a somewhat pointed observation: "The capital was fixed, in fact, upon a thinly-settled frontier, at a point the speculative, rather than the actual, centre [*sic*] of the state." Frederick Law Olmsted, *A Journey through Texas, or a Saddle-Trip on the Southwestern Frontier* (New York: Dix, Edwards and Co., 1857), 110.

5 During the period of construction, the Hills sold five slaves worth a total of $2,000, signed a mortgage in November 1855, and signed an additional deed of trust in February 1856. Hafertepe, *Abner Cook*, 113.

6 Mills Lane describes the design and construction of Milford in *Architecture of the Old South: Greek Revival and Romantic* (Savannah, GA: Beehive Press, 1996), 170–75. Lane quotes a letter from Potter to Manning dated May 12, 1839, in which Potter refers to specific Lafever plates in his description of the trim details.

7 Sanborn Fire Map, Austin, Texas, sheet 2, 1877, Sanborn Fire Map Collection, University of Texas at Austin. These structures unfortunately are no longer extant.

8 The 1877 Sanborn Fire Maps also provide evidence that few dwellings were built of stone during this early period. Wooden-frame residences were the most numerous, with brick the second (and more expensive) choice. Later in the century, dressed stone became more common for residential construction, and as a result later maps document an increased use of stone.

9 Courthouse contract, 1855, County Clerk Collection, Travis County Archives, Austin, Texas.

10 I thank historic preservation architect John Volz for studying the Historic American Buildings Survey (HABS) drawings of the Neill-Cochran House. Based on those drawings, it appears that the house required 526.13 perches of rough-cut stone, not including the foundations and cellar. Approximately 550 perches conservatively estimates the amount of stone required for the entire project.

11 Kenneth Hafertepe calculated this value by comparing the Travis County tax record for 1856 against the recorded purchase price in 1855 for the original lots of land. Hafertepe, *Abner Cook*, 113.

12 The first floor now has a brick floor that is several feet above the original dirt floor, due to subsidence in the intervening years. Neill-Cochran House Museum Archives, Austin, Texas.

13 John Davis, "Eastman Johnson's Negro Life at the South and Urban Slavery in Washington, D.C.," *The Art Bulletin* 80, no. 1 (March 1998): 67–92.

14 "1880 U.S. Federal Census," Roll 1329, Page 217B, Enumeration District 133, Database, https://www.ancestry.com.

15 "1900 U.S. Federal Census," Roll 1673, Page 9A, Enumeration District 0089, Database, https://www.ancestry.com.

16 The Cochrans' 1900 addition did not alter the design of the 1856 house, other than to turn four upstairs windows into doors.

From the Palaces of Berlin to the Texas Frontier: The Furniture Designs of Prussian Architect Karl Friedrich Schinkel

Serena Newmark

Having long been employed by the Foreign Office as the supervisor of historic buildings, I was ordered to turn the Palace over to the new Third Reich Minister of Propaganda [Joseph Goebbels] which I did in the early afternoon of the 13th of March 1933. . . . The last time I saw the palace was at the end of the war, when I stood before a mountain of rubble.[1]

—Johannes Sievers, East Berlin, 1966

Berlin today, almost thirty years after the fall of the Berlin Wall, is a city rebuilt and restored. Contemporary visitors to Berlin's famous Museum Island enter a cityscape that looks almost as it did in the nineteenth century, when the great architect Karl Friedrich Schinkel was the unquestioned tastemaker of the German-speaking world. In the heart of the old Prussian capital, pedestrians can cross a Schinkel-designed bridge to visit the museum that he designed or attend a service in a church that he constructed. However, alongside the beauty of modern Berlin, countless memorials attest to the city's more recent and tragic history. This was a city whose grandest buildings were reduced to "mountains of rubble" at the end an unspeakably horrific war, and whose citizens were torn from one another in peacetime by a heavily guarded concrete wall. Nevertheless, it is in Berlin, in its palaces before they were destroyed and in the libraries and archives of former East Berlin, that an interesting and previously unknown story of Texas material culture begins.[2]

*Fig. 1. Karl Wanschaff after a design by Karl Friedrich Schinkel, **Prussian Klismos Chair**, 1829–30, mahogany with maple inlay, formerly Palais Kaiser Wilhelm I, Berlin; Johannes Sievers, Wannsee, Berlin; now unknown whereabouts.*

Decades before unification and a century before the Second World War, the Germanic countries enjoyed a period of relative peace and prosperity that fostered a great flowering of the arts. In the 1820s and 1830s, victorious after the final defeat of Napoléon Bonaparte, German monarchs embarked on building campaigns that celebrated the wealth and power of their cities. While regional designers, including Leo von Klenze in Bavaria and Georg Ludwig Friedrich Laves in Hanover, were celebrated by local monarchs, the most influential German designer and architect of this period was unquestionably Karl Friedrich Schinkel, Director of Building for all of Prussia. Schinkel was awarded almost every honor that an early nineteenth-century European architect could receive. He was a member of the academies of his native Prussia as well as those of France, Bavaria, Britain, Russia, Austria, and Denmark.[3] Schinkel's popularity has never waned, and only Michelangelo Buonarroti and Frank Lloyd Wright can claim more books published on their respective architectural achievements.[4]

As Berlin's premier architect and the personal favorite of King Friedrich Wilhelm III, Schinkel filled Prussia with palaces and civic buildings, and designed military medals, weapons, textiles, ceramics, and furniture. As an instructor at Berlin's Bauakademie and through the pattern books that he published, Schinkel trained a generation of Prussian craftsmen. Most important, for the German-speaking world, Schinkel stood as a bridge between the age of vernacular hand construction and the era of large-scale factory production. While the citizens of Germanic kingdoms began the process of moving toward unification, Schinkel defined a unified German architecture and design aesthetic.

The mid-nineteenth century was also a time of mass immigration into the United States from many European countries, Germanic countries being no exception. Prussian immigrants found new homes in North America and elsewhere, sometimes fleeing unfavorable political climates in Europe and sometimes merely in search of economic opportunity. They left in both organized groups and as individuals, often with the aid of German-language immigration guides containing practical information about purchasing travel tickets, exchanging currencies, and finding employment once settled abroad. Texas, with its promise of access to inexpensive farmland, became a new home for many German immigrants.

After arriving in Texas, German-speaking immigrants settled in larger cities as well as in small towns such as Fredericksburg and New Braunfels, places that have retained many original German street names. Prussian immigrants did not leave their culture behind, ready to start afresh. In many ways, they brought their culture with them. When traveling through Texas in the 1850s, Frederick Law Olmstead, the designer of Manhattan's Central Park, remarked how culturally sophisticated he found the German-born residents of Texas to be:

On the walls there was hung a very excellent old line engraving of a painting in the Dresden Gallery, two lithographs, and a pencil sketch, all framed in oak . . . Madonnas upon log-walls; coffee in tin cups upon Dresden saucers; a Beethoven symphony on the grand piano; a bookcase half filled with classics . . . the sterling education and high-toned character of the fathers will be unconsciously transmitted to the social benefit of the coming generation.[5]

Cultural sophistication among German immigrants in Texas was not confined to their tea saucers and living-room symphonies; knowledge of European high culture also translated into economic success for German-born cabinetmakers. In the mid-nineteenth century, German-born residents accounted for only 6 percent of the Texas population, yet they made up a full third of working cabinetmakers in the state.[6] The only plausible explanation for the disproportionate professional success of German cabinetmakers in Texas is that they made use of particular advantages that they had acquired before emigrating.

The major advantage they possessed was the ability to make local copies of furniture designed for the finest royal palaces of Berlin by the greatest of all German nineteenth-century architects, Karl Friedrich Schinkel. Any competent cabinetmaker can create a piece of furniture from a design published in a well-illustrated pattern book. Thomas Chippendale's furniture designs were re-created around the globe by virtue of having been published in *The Gentleman and Cabinet-Maker's Director* (1754). The same fate can be said of furniture designs published by Percier and Fontaine, Thomas Sheraton, and several others. Schinkel published a volume of his furniture designs as well, but these were not the ones re-created by Prussian immigrants in Texas.

The furniture designs that Schinkel published were for chairs with highly intricate carving, and required yards of fine fabric for upholstery and often custom-fit ormolu mounts. Such luxurious furniture could have been purchased only by royal or very wealthy patrons and was certainly far out of reach for those buying furniture in nineteenth-century Texas. The Schinkel-designed chairs that appear frequently in Texas, made by cabinet-makers known and unknown, are copies of those used as practical and portable overflow seating in royal palaces. These chairs, which were also re-created by local cabinetmakers for non-royal residences throughout Germany,[7] were constructed after Schinkel designs that the master never published.

How Prussian immigrants abroad, as well as small-town German cabinetmakers who remained in Europe, knew how to make these palace chairs is, at present, unknown. Of the known cabinetmakers who made Schinkel chairs in Texas, no documentation in

Germany links them to specific training or employment in Prussia. A few baptismal records, a scattering of names on a military list, and a few home addresses can be found, but records of students studying at Schinkel's Berlin Bauakademie or who apprenticed with esteemed Berlin cabinetmaking firms are in short supply and seemingly provide no references to those who later lived in Texas.[8] Although we cannot be sure exactly how Prussian immigrant cabinetmakers learned to re-create chairs designed for Berlin's palaces, learn they did, and they made them for decades after the originals were first produced in Berlin.

The original chairs, built in the late 1820s and early 1830s, were magnificent. They were created of mahogany that had been imported from the Caribbean at great expense and were adorned with delicate lines of maple inlay. These chairs were made to Schinkel's designs by the esteemed cabinetmaking firm of Karl Wanschaff, a *Tischlermeister* or master craftsman,[9] and the superb handcraftsmanship of their construction was second to none. However, as with so many of Germany's artistic treasures, they are virtually all known today only through photographs. The expertly designed and constructed chairs were created for the Palais Kaiser Wilhelm I and the Palais Prinz Albrecht, which, along with many great buildings in central Berlin, were used as offices by the Nazis after they came to power in 1933. The palaces were naturally primary targets for air strikes by Allied forces, and by the end of the war they were reduced to mountains of rubble.

Neither the Palais Kaiser Wilhelm I nor the Palais Prinz Albrecht was originally designed by Schinkel. The Palais Kaiser Wilhelm I had originally been built in the late seventeenth century and had several different inhabitants before being acquired by the Prussian monarchy. Schinkel, always a favorite of the Hohenzollern royal family, was hired to renovate and refurnish the palace in the late 1820s for the use of Prince Wilhelm.

Upon the death of his father, the prince became King Wilhelm of Prussia and later the first German emperor, Kaiser Wilhelm I. The palace was known as the Palais Kaiser Wilhelm I until its destruction by Allied bombs in the Second World War. Efforts to rebuild the palace began in the 1960s, with the most recent renovation being the reconstruction of the Neoclassical pergola in 2007. Today, the reconstructed palace houses the law school of Berlin's prestigious Humboldt University.

In their heyday, the Palais Kaiser Wilhelm I and the Palais Prinz Albrecht displayed the latest and most fashionable high-court Prussian furniture. Schinkel, as the unquestioned Prussian master of architecture and design, created interiors with exquisite care. He went on trips throughout Europe and sketched at the foot of the great architectural monuments of antiquity and the Renaissance. His extensive travels throughout industrialized Great Britain helped shape his knowledge of how designs from the classical world could be brought into the present day and updated for the budding industrial era. Schinkel filled so much of fashionable Berlin with Neoclassical buildings that it was dubbed "Athens on

the River Spree." Schinkel planned each interior elevation to be as harmonious as possible. Decorated walls and ceilings, as well as windows and draperies, were consciously planned in concert with interior furniture so that no element in a room overshadowed or overwhelmed any other. Although Schinkel created ornate furniture that was covered with gilding and sported heavy silk tassels, much of the furniture he created for the private use of the royal family was less showy in appearance. These furnishings often displayed the beauty of the wood itself. These simple, harmonious, and relatively geometric designs required fine craftsmanship that could be provided only by a well-trained and experienced cabinetmaker, making them not dissimilar from the neat and plain furniture favored at the same time in the American South.

Three Schinkel chair designs found in Berlin palaces are known to have been later reproduced in Texas. The first is a straightforward and practical Prussian adaptation of the ancient Greek klismos chair (fig. 1). Countless designers around the world created their own versions of the klismos chair, as Neoclassical styles were internationally popular in the first half of the nineteenth century. Schinkel's version is remarkable for its graceful simplicity as well its design emphasis on comfort and utility. Although the chair's sabre legs and curved back unmistakably reference the ancient klismos form, the chair does not display the extreme bending of the legs and almost semicircular wrapping of the crest rail so often found in English and Italian nineteenth-century klismos chairs. Although other designers of his era created dramatic klismos chairs that more closely resembled ancient Greek originals, Schinkel's version merely nodded to the ancient world while embracing the modern demands put on heavily used furniture. As mahogany is a very heavy wood, the chairs were designed with caned seats, which made them significantly lighter, more portable, and more comfortable for sitting. Contemporary observers remarked that they had very deep seats and were, indeed, surprisingly comfortable.[10] Although a caned seat might at first seem to have been an economy, as it spared a large piece of expensive imported mahogany, the opposite was true. The labor-intensive installation of the caned seat made the chairs more costly to construct but resulted in a piece of furniture that was both luxurious and practical. The two other Schinkel chairs found in Texas are versions of the same chair with more decorative midrails, one with a double-vase and central-ball midrail (fig. 2), and the other with a central-diamond midrail (fig. 3). The double-vase and central-ball chair was originally made for the Palais Kaiser Wilhelm I.[11] The diamond-back version was originally created for the Palais Prinz Albrecht, once only a brief walk from the Palais Kaiser Wilhelm I.

This most basic form of the Schinkel klismos chair, with a midrail curved outward to accommodate the sitter's back but with flat horizontal surfaces, was built by the dozens, and was originally intended for use, at least partly, by palace servants.[12] Two

Fig. 2. Karl Wanschaff after a design by Karl Schinkel, Double-Vase and Central-Ball Chair, 1829–30, mahogany with maple inlay, Palais Kaiser Wilhelm I, Berlin (demolished).

Fig. 3. Karl Wanschaff after a design by Karl Schinkel, Central-Diamond Chair, 1831, mahogany with maple inlay, Palais Prinz Albrecht, Berlin (demolished).

chairs, made in New Braunfels of local Texas walnut, appear to be line-for-line copies of the original chair designed by Schinkel.[13] Heinrich Scholl, an immigrant cabinetmaker from Prussian Nassau, built the chairs for use in his family home (fig. 4), and they are still owned by his descendants. Scholl was born about the time the original Schinkel chairs were constructed in Berlin, and he arrived in Texas at the tender age of twenty-two.[14] Nevertheless, this pair of chairs, as well as other chairs and tables that he created, displays an extraordinarily sophisticated approach to cabinetmaking. The subtly of the contours on his chair backs and legs, the delicate inlay, and the precise curves on his tables all indicate that Scholl had received cabinetmaking training in the finest of European styles.[15]

The version of the chair with an identical silhouette but with a decorative double-vase and central-ball midrail was also designed by Schinkel for use in the Palais Kaiser Wilhelm I.[16] This more elaborate double-vase and central-ball version of the chair was used in countless numbers throughout the palace, was very light and portable, and was comfortable for sitting. All recorded Berlin examples had caned, rather than

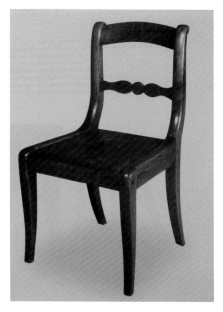

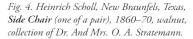

Fig. 4. Heinrich Scholl, New Braunfels, Texas,
Side Chair *(one of a pair), 1860–70, walnut,*
collection of Dr. And Mrs. O. A. Stratemann.

Fig. 5. Jacob Schneider, Fredericksburg, Texas,
Side Chair *(one of six), 1860–70, walnut,*
collection of Mrs. Lewis Dolezal.

solid, seats. An early image of the double-vase and central-ball chairs in situ shows the chairs, without any additional upholstery or cushions, along the back wall of the elegant muslin-draped parlor of Princess (later Empress) Augusta.[17]

Several versions of the double-vase and central-ball chair were made by Prussian immigrants in Texas from about 1860 to 1870. The chairs with proportions most closely resembling those of the original Schinkel chairs are the six surviving examples made by Jacob Schneider (fig. 5).[18] Schneider created these chairs in the 1860s for the use of his family, and his descendants still own them today. Unlike the original Berlin chairs, Schneider's chairs are made of locally sourced walnut and have solid wood seats without caning. Although solid-seat chairs would have been heavier and less comfortable for sitting, they undoubtedly served the specific Schneider household purpose for which they were built. Schneider was born in Prussia in 1823 and served in the Prussian military before immigrating to Texas in 1853.[19] Although there are no known records of his cabinetmaking training, Schneider was a member of the generation of Prussian artisans who trained in the era when Schinkel was the unquestioned master of design.

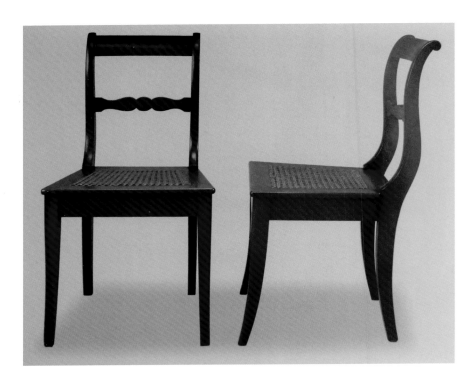

Fig. 6. Johann Michael Jahn, New Braunfels, Texas, **Pair of Chairs,** *c. 1860, walnut and cane, the Museum of Fine Arts, Houston, the Bayou Bend Collection, gift of William J. Hill, B.2007.13.1,.2.*

Other Texas examples of the double-vase and central-ball chair include those made by the most celebrated of all German-Texan cabinetmakers, Johann Michael Jahn (fig. 6).[20] This pair of chairs, made of walnut and cane seats, is found in the Bayou Bend Collection of the Museum of Fine Arts, Houston. The slender sabre legs and thin stiles found on the Jahn chairs are more faithful to those of the Berlin chairs than are the relatively wide elements of Schneider's chair. The caning and wraparound lip found on the seats of the Jahn chairs are also taken directly from the original Berlin chair design. However, Jahn's approach to the double-vase and central-ball midrail is not quite as faithful as that employed by Schneider. On Schinkel's original Berlin chairs and the Schneider versions, the midrail "vases" gently flare as they join the inner surfaces of the stiles. In the Jahn chairs, and all other known Texas versions, the curve of the vase is interrupted by a short rectangular section, with flat horizontal surfaces on top and bottom. Born in the Prussian town of Barth in 1816, Jahn immigrated to Texas in 1844 as a single man traveling without any family.[21] The finely crafted furniture that he created later in

Texas stands as evidence that Jahn acquired training in creating the latest fashionable Schinkel furniture before leaving Europe.

Five other double-vase and central-ball chairs are known to have been created in Texas. One chair, attributed to Jahn, was created with a solid seat and is found in a private collection in New Braunfels, where Jahn lived for many decades. A private collection in San Antonio houses four versions of the chair made of cherry, one with a solid seat and three with caned seats. While these chairs are unmistakably Prussian klismos chairs with double-vase and central-ball midrails, the somewhat straightened sabre legs and the inexact carving of the midrails suggest that they were not made by as masterful a hand as that of Jahn or Schneider.[22] The chairs are all, nonetheless, evidence that many young cabinetmakers in Prussia were trained to create furniture in the style of the great master Karl Friedrich Schinkel, and that they brought their knowledge of Berlin court furniture to their new homes in Texas.

Not far from the Berlin site of the Palais Kaiser Wilhelm I stood the Palais Prinz Albrecht. The palace was originally built in the mid-eighteenth century and was updated and refurnished by Schinkel in the early 1830s for Prussian Prince Albrecht on the occasion of his marriage to Marianne von Oranien-Nassau, daughter of the Dutch king. A century later, the Palais Prinz Albrecht was used by the Nazis as the headquarters for the Schutzstaffel, which is commonly known as the SS and was the organization primarily responsible for the war crimes committed at Nazi concentration camps. Although parts of the outer palace walls survived the bombing campaigns of the Second World War, because of the building's repellent association with the SS, the American military decided to destroy what was left of the building and cleared the ruins in 1955. The Palais Prinz Albrecht has never been rebuilt, and on its site today stands the Topography of Terror Documentation Center, which chronicles the crimes of the Nazi state.

The marriage between the original inhabitants of the refurnished palace, Prince Albrecht and Princess Marianne, would be an unhappy one that would end in divorce. Prince Albrecht later entered into a morganatic marriage with a woman of much lower rank and was forced to leave Berlin court society. However, when the Palais Prinz Albrecht had been newly renovated by Schinkel, it displayed the latest in royal domestic fashion as could only be designed by the great Prussian master architect. Every centimeter of the palace interior was designed by Schinkel to reflect a human-scale residence with all textiles, wall paintings, and furniture in perfect harmonious concert with one another. As with the Palais Kaiser Wilhelm I, Schinkel designed a variation on the Prussian klismos chair specifically for the Palais Prinz Albrecht. This chair was also constructed of mahogany and decorated with simple but delicate lines of maple inlay. The Prussian klismos silhouette and caned seat are identical to those of other Schinkel palace chairs,

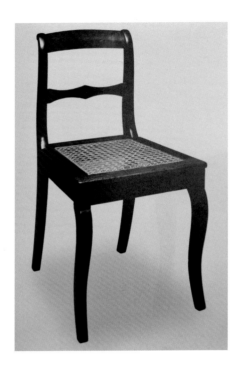

Left:
Fig. 7. Maker unknown, **Side Chair** (one of a set
of ten), 1860, walnut, collected in New Braunfels,
Texas, collection of Mr. Ted James.

Opposite page:
Fig. 8. After a design by Karl Friedrich Schinkel,
Salon Folding Table or Sofa Table, c. 1830,
mahogany with maple inlay and ormolu mounts,
Palais Prinz Albrecht, Berlin (demolished).

but the Palais Prinz Albrecht chairs display a distinctive central-diamond midrail. Like
their counterparts in the Palais Kaiser Wilhelm I, the central-diamond chairs were used as
overflow seating, and a nineteenth-century watercolor shows the chairs stationed along the
perimeter of the palace's oval dining room, ready to be called into service when needed.[23]

There were several chairs made in Texas about 1860 to Schinkel's central-diamond-
midrail design, but unfortunately all are by unknown craftsmen. Ten chairs belong to a
single unusually large matching set, and all are made of walnut and currently housed in
a private collection in San Antonio (fig. 7). The ten matching chairs have caned seats, as
did the original Berlin chairs. Although their central-diamond midrails are not decorated
with inlay, nor are their curves as sweeping and dramatic, the resemblance is unmistakable.
The chairs from the other known set are a bit larger, and have solid wood seats and
unusually slender central-diamond midrails.[24] Unlike the chairs designed for the Palais
Prinz Albrecht, which had sabre front legs common to most klismos chairs, the Texas
versions all display vertical front legs carved in a shape reminiscent of the nineteenth-
century version of the French cabriole leg. Schinkel often found inspiration in French
design and used this leg shape in other pieces of furniture, but not on the utilitarian
simplified klismos chairs that he built for the palaces of Berlin.

Schinkel also designed a grand but welcoming parlor for the Palais Prinz Albrecht. With a patterned carpet and comfortable upholstered furniture, this room was designed for Princess Marianne to receive her personal guests. Positioned within arm's reach of a luxuriously upholstered sofa stood an exquisite mahogany sofa table (fig. 8). The top of the sofa table was in the shape of a rectangle with dramatically curved corners, the ends of which can be folded down or secured in the horizontal plane as needed. Each end of the table was held aloft by a set of four volutes, gentle S curves symmetrically paired to resemble the shape of a lyre from classical antiquity, with one lyre turned upward and one downward. The supports are joined together by a single crossbar, and, as with the many chairs that Schinkel designed for Berlin palaces, the beauty of the mahogany is accented with thin lines of maple inlay. Unlike the chairs, the sofa table was additionally adorned with rosette and foliate forms. Although a twentieth-century art historian described them merely as "goldbronze,"[25] suggesting that they may have been wood that was either painted or covered in gold leaf, comparisons to surviving Schinkel furniture indicate that they may actually have been specially fitted ormolu mounts.

Just as only one table was created for the Palais Prinz Albrecht, similarly only one known version of the table was made in Texas. It was created in Fredericksburg about 1860 by Engelbert Krauskopf (fig. 9), who was born in Prussia in 1820 and trained as a cabinetmaker before immigrating to Texas in 1850.[26] Krauskopf was primarily known in Texas as a gunsmith rather than a cabinetmaker, but the table was treasured and kept in the family home for several generations. Although the Texas table is made of relatively

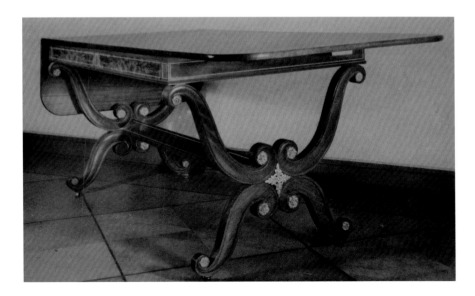

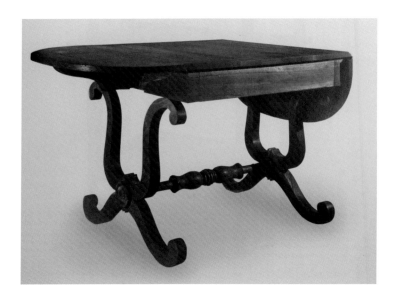

*Fig. 9. Engelbert Krauskopf, Fredericksburg, Texas, **Sofa Table**, 1860, walnut and pine, collection of Mrs. Schatzie Crouch.*

humble local walnut with pine as a secondary wood, the shape and the craftsmanship are virtually identical to the palace version. As with the Berlin original, the Texas version consists of a rectangular top with steeply curved corners and folding sides. The Fredericksburg table similarly rests on a pair of double lyres, each consisting of a large lyre turned upward and a smaller one turned downward. With no delicate inlay or ormolu mounts, the Texas table is stabilized by a solid stretcher, which had been carefully carved on a lathe into a three-dimensional manifestation of Schinkel's oft-used motif, the double vase and central ball.

Although the vast majority of original Berlin Schinkel furniture did not survive the bombing of the Second World War, local vernacular versions of the furniture have been found wherever Prussian cabinetmakers chose to set up their businesses, both through-out Europe and in many locations abroad. Although this furniture, often made very far from Berlin, is an important part of the understanding of Schinkel's influence and that of nineteenth-century Germanic Neoclassicism in general, it cannot fully replicate the feel of a purposefully designed Schinkel interior. Schinkel did not design furniture in isolation—it was always planned to coordinate with the walls, windows, and textiles found in a specific location. A Schinkel chair, no matter how faithfully copied in Central Texas, is still decontextualized from a Schinkel room.

*Fig. 10. Rudolph Melchior, **Foyer of the McGregor-Grimm House**, c. 1861, originally in Wesley, Texas, now in the Winedale Historical Complex, Round Top, Texas, the Dolph Briscoe Center for American History, the University of Texas at Austin.*

Nevertheless, the well-preserved interior house painting of Prussian immigrant Rudolph Melchior offers a glimpse into the nineteenth-century Prussian Neoclassical interior. Melchior, his brothers, and his father arrived in Texas as trained Prussian decorative painters. The McGregor-Grimm House in the collection of the Winedale Historical Complex displays elaborate Prussian Neoclassical wall painting by Melchior. Visitors enter through the foyer and are greeted on either side by rows of Neoclassical pilasters (fig. 10), accented by acroteria. The column bases are remarkably similar to those that

Fig. 11. Karl Friedrich Schinkel, **Object Design for the Palais Prinz August** *(detail), 1815–17, ink and graphite on paper, Schinkel Archive, Inv.-Nr.: SM B.20, Kupferstichkabinett, Berlin State Museums.*

Opposite page:
Fig. 12. Karl Friedrich Schinkel, **Scale Drawing of the Ornament on the Exterior Wall of the Erechtheion** *(detail), 1821–30, lithograph, Schinkel Archive, Inv.-Nr.: 33.22-1991, Kupferstichkabinett, Berlin State Museums.*

Schinkel designed for the Palais Prinz August (fig. 11). The acroterion was another favorite decorative element of Schinkel's. As a young man, he had sat at the base of the monuments on the Acropolis and sketched from the ancient masters, and then later published drawings of acroteria for the use of his design students in addition to using them in his own architecture (fig 12). The upstairs East Room of the McGregor-Grimm House displays a long decorative pattern of scrolling vines, with one tendril circling clockwise and culminating in a single central blossom, followed by another circling counter-clockwise and also culminating in a single central blossom. The vine continues, implying but never completing a full circle (fig. 13). This scrolling pattern was also found in the ancient world and was reimagined and reused by the Renaissance masters for use in the Vatican and other esteemed buildings and palaces. Schinkel sketched from both ancient and Renaissance versions on his grand tours throughout Greece and Italy, and he established the pattern as an element for use in Prussian Neoclassical building. Schinkel's sketch for a wall decoration in the Palais Prinz Albrecht (fig. 14) shows his intention to use the alternating spiral pattern much as it was used later by Rudolph Melchior in Texas. An undated painted sketch by the later Hanoverian Neoclassical architect Georg Ludwig Friedrich Laves (fig. 15) shows a version of the same pattern and acanthus-leaf shape remarkably similar to those used in Texas by Melchior.[27]

Fig. 13. Rudolph Melchior, **Upstairs East Room of the McGregor-Grimm House,** *c. 1861, originally in Wesley, Texas, now in the Winedale Historical Complex, Round Top, Texas, the Dolph Briscoe Center for American History, the Universty of Texas at Austin.*

Fig. 14. Karl Friedrich Schinkel, **Design for a Public Room in the Palais Prinz Albrecht** *(detail), 1830–31, ink and graphite on paper, Schinkel Archive, Inv.-Nr.: SM 22a.21, Kupferstichkabinett, Berlin State Museums.*

Fig. 15. Georg Ludwig Friedrich Laves, **Watercolor Sketch***, undated, Laves Nachlass, Stadtarchiv Hannover.*

The architectural interiors of Karl Friedrich Schinkel first became the subject of extensive art-historical research in the early 1910s, and significant academic interest in early Texas furniture and interiors followed in the midcentury. With the near total destruction of Berlin in the Second World War, and the subsequent inaccessibility of documents in a divided Germany, there has been little time or opportunity, on either the German or American side, to incorporate an understanding of the craftsmanship of Prussian immigrants in Texas into the greater understanding of Prussian Neoclassicism and the oeuvre of master architect Schinkel. In 1981, for the two hundredth anniversary of Schinkel's birth, museums in both West and East Berlin held celebratory exhibitions, but because of the political divide, their respective staff members could not coordinate with one another. With the combined resources of a reunited Germany and the ever-shrinking world afforded by the Internet age, the opportunity has come to reimagine the design legacy of Prussia and Schinkel as one that includes Prussian craftsmen who settled in Texas and elsewhere around the world.

Notes

1 Johannes Sievers, *Aus Meinem Leben* (East Berlin: unpublished manuscript, 1966), 359–60. Translation by Serena Newmark.

2 Serena Newmark, "Prussian Furniture and Pioneers: Karl Friedrich Schinkel's Legacy in Texas," *Furniture History Society Newsletter*, no. 201 (February 2016): 2–8.

3 Rand Carter, "Karl Friedrich Schinkel, 'The Last Great Architect,'" in *Collection of Architectural Designs by Karl Friedrich Schinkel* (Chicago: Baluster Books, 1984), 27.

4 Barry Bergdoll, *Karl Friedrich Schinkel: An Architecture for Prussia* (New York: Rizzoli, 1994), 8.

5 Frederick Law Olmsted, *A Journey through Texas, or a Saddle-Trip on the Southwestern Frontier* (New York: Dix, Edwards and Co., 1857), 189, 430.

6 Lonn Taylor and David B. Warren, *Texas Furniture: The Cabinetmakers and Their Work, 1840–1880*, vol. 1, rev. ed. (Austin: University of Texas Press, 2012), 10.

7 Charles L. Venable, "Texas Biedermeier Furniture," *The Magazine Antiques* 127 (May 1985): 1170.

8 Achim Stiegel, *Berlin Möbelkunst vom Ende des 18. Bis zur Mitte des 19. Jahrhunderts* (Berlin: Deutsche Kunstverlag, 2003).

9 Johannes Sievers, *Die Möbel* (East Berlin: Deutsche Kunstverlag, 1950), 48.

10 Ibid., 52.

11 Ibid.

12 Ibid.

13 Taylor and Warren, *Texas Furniture*, 1:150.

14 Ibid., 1:325.

15 Ibid., 1:209, 216.

16 Sievers, *Die Möbel*, 39, 52.

17 Ibid., Image 261.

18 Taylor and Warren, *Texas Furniture*, 1:151.

19 Ibid., 1:324.

20 Lonn Taylor and David B. Warren, *Texas Furniture: The Cabinetmakers and Their Work, 1840–1880*, vol. 2 (Austin: University of Texas Press, 2012), 122.

21 Taylor and Warren, *Texas Furniture*, 1:310.

22 Ibid., 1:147–49.

23 Johannes Sievers, *Bauten für Prinzen August, Friedrich und Albrecht von Preussen* (East Berlin: Deutsche Kunstverlag, 1954), 165, fig. 132.

24 Taylor and Warren, *Texas Furniture*, 1:145–46.

25 Sievers, *Die Möbel*, 58.

26 Taylor and Warren, *Texas Furniture*, 1:225, 313.

27 Georg Ludwig Friedrich Laves, *Undated Watercolor Sketch*, Laves Nachlass, Collection 1.3, Verschiedenes/Innenraum, Drawing 1548, Stadtarchiv Hannover, Hanover, Germany; Kenneth Hafertepe, *The Material Culture of German Texans* (College Station: Texas A&M University Press, 2016), 274–76.

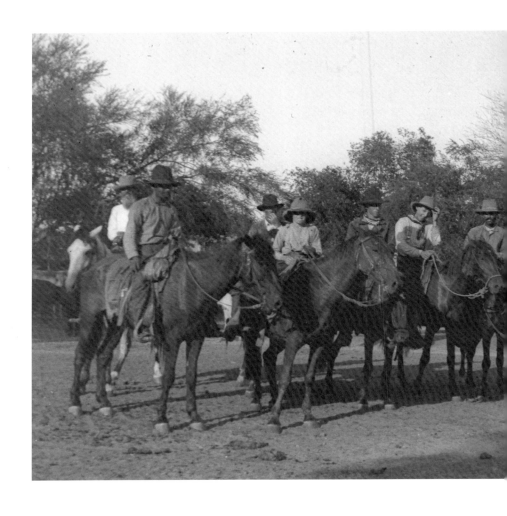

Fig. 1. Unknown photographer, **Vaquero and Cowboy Crew, Rock Ranch**, *Nueces County, Texas, c. 1920, silver photographic print from glass plate negative, Witte Museum, San Antonio.*

Making the Texas Cowboy and the Tools of the Endeavor

Bruce M. Shackelford

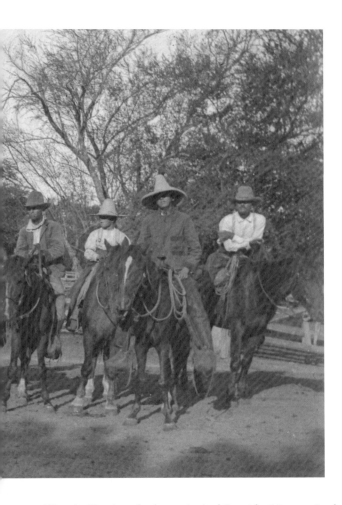

Hernán Cortés and other uninvited Spanish visitors arrived at what is now the Mexican Gulf Coast in 1519 with sixteen horses and skilled horsemen with the accoutrements needed to ride them. Chronicler Bernal Diaz wrote that horses "at that time were both scarce and costly."[1] The melding and change of saddlery, tack, and apparel used by working horsemen for managing cattle altered the history of North and South America and created an American icon in the thorn brush of South Texas: the American cowboy (fig. 1).

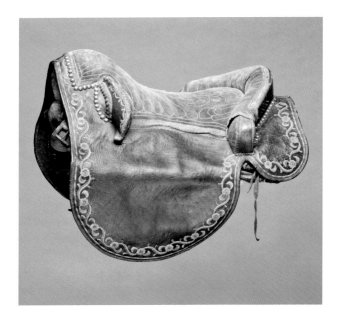

Fig. 2. **Estradiota Saddle**, *La Nueva España or New Spain, late 1600s, leather, iron, wood, velvet, cactus fiber, and silk, Witte Museum, San Antonio, gift of Major General G. C. Brant.*

Riding into North America

The Spanish invaders rode in three styles. *Estradiota* and the heavier *la brida* came from the European tradition of fighting with long lances from horseback. The rider's legs extended forward to brace for impact. The saddle had a high rear cantle, and the cinch was placed forward, holding the saddle on the horse. The stirrups were narrow and often made from cast or forged iron. The bit had a jointed mouthpiece and two "split" reins. The horseman wore spurs with spinning rowels on the back of tall leather boots.[2] The *piteado* embroidery of cactus fiber and silk decorating one Spanish colonial estradiota saddle indicates its Mexican origin (fig. 2).

The third riding style, introduced into Spain by the Moors, was called *jineta*. The jineta horseman stood in the stirrups to better control throwing javelins and using other weapons, and the horses were trained for rapid actions, like the "roll-back" and "sliding stop" that are a part of present-day reining movements for working livestock.[3] The bit in the horse's mouth was a fixed bit, often with a ring encircling the lower jaw, and a high port on the mouthpiece. The bit was connected to the rider's hands by closed reins, or a loop. The stirrups were wide and flat, making them easy to stand in. The spurs were called prick spurs and were favored by early Spanish *conquistadores*. Boots, when they were worn, were lighter and shorter than those worn in Europe, and shoes were worn more often than boots.[4] The equestrian goal of the jineta horseman was

Fig. 3. Felix á Casta, engraver, **Antonio Galvam d'Andrade, Arte da Cavallaria 1678, Jineta Horseman Picking up a Handkerchief,** *Portugal, Quarto, engraving, 7 ¾ x 11 ⅜ in. (19.7 x 28.9 cm).*

to become one with the horse in movement, direction, and thought.[5] This description of a jineta horseman mirrors that of a skilled South Texas cowboy or *vaquero*: "The jineta horseman sits as if part of the horse. He rides with his knees somewhat bent, his legs relaxed yet continually caressing the horse's sides, his calves and spurs ready to be brought into play whenever needed. He sits with an open chest, his upper body at ease, his face steadfast and serene, looking between the ears of his horse, a position which enables him to direct his mount with authority and perfect harmony."[6]

Great Spanish horsemen were said to ride *sillas ambas,* meaning either seat. Spanish expeditions in northern Mexico in the sixteenth and seventeenth centuries often carried both estradiota and jineta saddles and a few of the heavily armored la brida saddles as well. The light, versatile jineta saddles and tack gave the horseman complete control of his actions, from saddling the horse and mounting to riding.[7] The equestrian skill of a seventeenth-century Portuguese jineta horseman snatching a handkerchief from the ground at a full gallop (fig. 3) was also a sport of vaqueros of Spanish Texas called *correr el gallo,* in which a rooster was snatched from the ground by the horseman at a full gallop.[8] This activity could not have been accomplished by a horseman riding estradiota or la brida.

Roping and Saddle Horns

By the late 1600s, a cattle-working skill developed that would change saddles, tack, and livestock handling and give birth to the Mexican vaquero and subsequently the Texas cowboy: the skill of throwing ropes from horseback.[9] Prior to ranching in eighteenth-century Mexico and Texas, long ropes, often sixty feet or longer, were hung off of an iron hook or spike (*espiga*) on the end of a ten- to twelve-foot pole and dropped over the head of a steer to catch the animal. The ropes were made from hemp or braided rawhide. Throwing ropes bastardized the traditional riding styles of estradiota and jineta with a new addition to saddle construction: a strong fork topped by solid horn on the front of the pommel.

In Mexico, processed and twisted maguey cactus fiber became another material for use in rope making, in addition to hemp and rawhide.[10] Maguey ropes performed best in hot and dry weather, when they were easy to spin and throw (fig. 4). In a cold and damp climate, maguey ropes became hard to handle. The ropes were often more than fifty feet long and wound around the horn, being loosened and tightened as needed in an action called *dar la vuelta*, taking a turn. The movement was called a "dally" by English-speaking cowboys.

Nineteenth- and twentieth-century Mexican and Texan vaqueros, trained in traditional Mexican roping skills, were experts unequaled in the world. They could bring an animal down slow and easy or rapidly trip it as needed. A good roper could perform either from horseback or standing on the ground. A great roper could trip a horse or steer with a rope tied around a saddle horn, or standing on the ground with the rope around his neck.[11] Mexican vaqueros and charros continue to rope today as they did in the nineteenth century.

Nineteenth-century South Texas cowboys used roping skills they learned from their Hispanic counterparts on the range. "The Blocker," a throw named for the legendary cattleman John Blocker, was a large loop thrown without the usual spinning or twirling

Fig. 4. Maker unknown, Mexico, **Maguey and Rawhide Ropes**, *19th century, Donald and Louise Yena Collection, Witte Museum, San Antonio.*

of the loop above the head. The Blocker loop was known from Texas to Canada by the late 1800s,[12] and it was probably adapted from a similar Mexican throw for tripping livestock. The *hoolihan* was another Mexican loop adapted by cowboys, and the name may be a corruption of the Spanish name Julián.[13]

South Texas brush-country cowboys changed roping to meet their needs; they used shorter ropes, forty feet or less, and the lines were tied off hard onto the saddle horn, in effect jerking down the steer. The rope was actually knotted around the saddle horn and did not slide like loose Mexican ropes. The cowboy who tied off "hard and fast" needed less skill, and the short ropes proved better for working in heavy confining brush than long ropes. On the open country of the central and northern plains and in Mexico, longer ropes continued in use, but short ropes dominated roping in South Texas and continue to do so today across the United States on ranches where cattle are still rounded up using ropes and in competitive arena events.

Images of Change

Until at least the early 1830s, horned saddles made south of the Rio Grande probably dominated stock work on ranches around San Antonio, Texas, and throughout the coastal bend from Tampico, Mexico, to Victoria and Goliad, Texas: what is still known as the brush country. The artist Lino Sánchez y Tapía created rare images of horsemen riding horned saddles in early Texas between 1827 and 1831. The images may be unique in their depiction of early nineteenth-century horsemen in the borderlands.

Jean Louis Berlandier was employed by the Mexican government as part of a team to explore and document the northeastern boundaries of the country recently separated from Spain in 1821. He was accompanied by Lino Sánchez y Tapía, who produced stylized costume plates, or *costumbristas*, from the expedition. The watercolors from the endeavor are signed by Lino Sánchez y Tapía, however, Tapía may have copied some of the images from other works made by Berlandier or another artist.[14]

Titles are inscribed on the images, with three exhibiting similar dress, and a fourth showing what can be regarded as *puro Mexicano* even today. The first, *Soldado Mexicano Presidial: Soldat des presidios des Etats Internes du Mexique*, represents a soldier in northeast Mexico, most likely attached to a local town garrison inland from the Gulf Coast (fig. 5). The second watercolor is titled *Ranchero de N. Leon y Tamaulipas: Habitant de la campagne des Etats du Nouveau Leon et de Tamaulipas* (A Rancher of Nuevo Leon and Tamaulipas, an Inhabitant of the Countryside of the States of Nuevo Leon and Tamaulipas, fig. 6). The third image is *Ranchero de Texas* (A Texas Rancher, fig. 7).

The three horsemen are depicted mounted on saddles with horns and *tapaderos*, or stirrup covers, to protect the riders' feet and stirrups from damage due to hanging in

Fig. 5. Lino Sánchez y Tapía, **Soldado Mexicano Presidial**, *c. 1830s, from bound book of watercolors; watercolor on paper, 12 ¼ x 8 ½ in. (31.1 x 21.6 cm), Gilcrease Museum, Tulsa, Oklahoma, GM 4016.336, Pl. I.*

Pl. XXXIV.

Ranchero de N. Leon y Tamaulipas.

Habitant de la campagne des états du Nouveau Leon et de Tamaulipas

Fig. 6. Lino Sánchez y Tapía, **Ranchero de N. Leon y Tamaulipas**, c. 1830s, from bound book of watercolors; watercolor on paper, 12 ¼ x 8 ½ in. (31.1 x 21.6 cm), Gilcrease Museum, Tulsa, Oklahoma, GM 4016.336, Pl XXXIV.

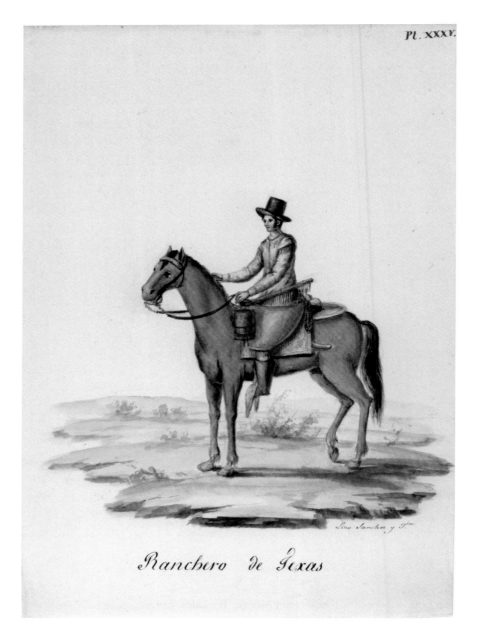

Pl. XXXV.

Ranchero de Texas

Fig. 7. Lino Sánchez y Tapia, **Ranchero de Texas**, c. 1830s, from bound book of watercolors; watercolor on paper,
12 ¼ x 8 ½ in. (31.1 x 21.6 cm), Gilcrease Museum, Tulsa, Oklahoma, GM 4016.336, Pl. XXXV.

the brush. The Texas rancher and the presidial soldier both carry rifles in fringed hide cases, and sword sheaths protrude from the lower edge of their saddle skirts. The Texas rancher is shown without spurs, while both the soldier and the Mexican rancher wear roweled spurs. Bags are attached to their saddle horns, and the horsemen wear tall "stovepipe"-style hats with wide brims.

The two ranchers clearly wear boots for protection. The rendering of the soldier's leg protection indicates that he may be wearing heavy leather leg guards over shoes. By the late nineteenth century, the heavy leg covers were called *polainas* and were worn in both Mexico and South Texas.[15] The ranchers and the soldier carry gourd canteens on the rear of their saddles. The rancher has a coiled rope by the canteen and wears a full suit of fringed hide clothing, while the soldier wears a military uniform jacket. Fringed leather outfits consisting of jackets and pants were still sold in El Paso in the late nineteenth century.[16] The three horsemen wear *armas* from their knees to their waists for protection from thorn brush. Armas were made of heavy leather and attached to the saddle horn and tied around the rider's waist.

The details in the illustrations show that the saddlery and dress of cowboys and vaqueros on the northeastern frontier of Mexico and South Texas were well established by 1830, including horned saddles with leather *mochilas* (one-piece saddle covers), square skirts, tapaderos covering stirrups, and armas. Armas were replaced by chaps less than thirty years later. All of the saddles illustrated have a feature that was gone from Texas and Mexican saddles within twenty years: the rear-protruding piece of leather called a *cola de pato* or duck's tail. The wide-brimmed hats, boots, and spurs worn by the horsemen continue to be the standard in the brush country today.

A fourth watercolor shows the saddlery and dress that emerged in Mexico, Texas, and New Mexico, where some similarities continued in the latter area until at least the late 1880s (fig. 8). The title and subject of this work is *Caporal de Hacienda*, a manager or foreman of a working cattle ranch or *hacienda*. If cattle needed to be roped and branded, the caporal had his vaqueros do the work. He managed the hacienda from horseback and directed the vaqueros. He was trained knowing the traditions, dress, and tack of Mexican horsemanship of the era.

The *caporal* wears riding dress that was adapted throughout early nineteenth-century Texas, New Mexico, and the Southwest, and he rides a saddle that is more like those seen forty years later in Texas than in Mexico. The saddle has a rounded horn and what appears to be a full mochila over the entire saddle. The caporal wears a long leather coat that is historically identified with the Mexican state of Tamaulipas, and a wide-brimmed hat with a rounded crown, clearly a fine *sombrero*. His shirt is of cloth with a high collar. He wears two pairs of trousers, with the darker outer pair made most likely of

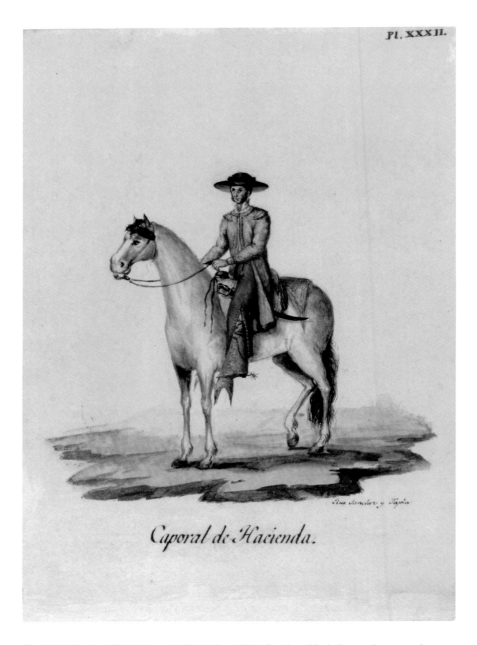

Pl. XXXII.

Caporal de Hacienda.

Fig. 8. Lino Sánchez y Tapía, **Caporal de Hacienda**, c. 1830s, from bound book of watercolors; watercolor on paper, 12 ¼ x 8 ½ in. (31.1 x 21.6 cm), Gilcrease Museum, Tulsa, Oklahoma, GM 4016.336, Pl. XXXII.

vegetal-tanned deerskin leather called *gamoosa*. The trousers are fastened above the knee with buttons, usually silver, and in the slit above his knee a white glimmer of cotton shows the undertrousers, or *pantalones*. Stamp-tooled soft leather *botas* protect the rider's legs from brush. Mexican horsemen wearing botas traditionally wore shoes instead of boots. Large roweled spurs spring from his heels. As seen in all the other Tapía illustrations, tapaderos cover the rider's stirrups. A sword hangs from his saddle at the ready.

Formal charro dress, worn since the mid-nineteenth century, is very similar to that of the caporal illustration. The practice of wearing cotton pantalones showing under leather split-side outer trousers and separate leather leg wraps was adapted by American Indian Navajo men of New Mexico and Arizona and can be seen in photographs made into the 1880s. Both the Mexican and the Navajo examples of the trousers often have decorative silver buttons.

Travel and Trade

Geopolitical changes through the South, Southwest, and the West dispersed "Spanish"- and "Texas"-pattern saddles. By the late 1830s, horned saddles called "Spanish saddles" were being advertised in Saint Louis, Missouri, and New York City newspapers.[17] Mid-nineteenth-century travelers on the Santa Fe Trail, and participants in the Texas Revolution (1835–36), the Mexican-American War (1846–48), and the California Gold Rush (1848–55) all rode horned saddles throughout the United States and North America, and saddle makers learned the skills of constructing horned wooden saddletrees and covering them with leather. Horsemen found the saddles easier for them to ride for long hours and easier on the horse.

Most existing Mexican examples from the 1830s to the 1850s represent the finest highly decorated saddles made in the era, unlike Texas-made working saddles of the time, which had only simple decoration, if any. One notable saddle with a smaller horn and heavy gullet for roping was owned by Jefferson Davis and brought back on his return from his service in the Mexican-American War between 1846 and 1847. The saddle is marked "BLUNN and WALKER. Saddlers / Austin" on the cantle.[18] By the late 1840s, "platter horned" saddles appeared and were called "Texas saddles" in letters and advertising. By the early 1850s, they were named "Hope" for a saddler in Washington County, Texas.

James Hope, an English cordwainer, or cobbler and leatherworker, migrated with his family from West Feliciana Parish, Louisiana, to San Felipe at Austin's Colony in 1824. Hope set himself up as a farmer and stock raiser, probably in Brazos County, and recorded his brand in 1826. His wife and nine children came with him.[19] Whether James worked leather in Texas, other than for himself and his family, is not known, but he

did have his tools. Like many leatherworkers, in addition to shoes and boots, he made leather-covered wooden trunks and other goods. James's son Adolphus also took up leatherwork, among other endeavors.

Adolphus Hope worked as a surveyor and lived in Washington County. He fought at San Jacinto, but other than in military rolls he is little mentioned in legal records until his death in November 1853 at the age of forty-three. The dispersal records of his estate give a glimpse into his trade and skills. Hope owned all of the tools needed to make saddles and saddletrees, including patterns, a shaving horse, a leather splitter, and a number of tanned hides of different types, all of which were purchased from the estate by his older brother Richard, who was a farmer.[20]

During Hope's life, his tree design, a Mexican-style design made for roping, spread throughout Texas and the southern states. R. J. Rice and J. H. Jackson of Austin advertised their rights to the use of the "Hope" saddle in an 1850 Texas newspaper.[21] Rice and Childers Saddlery, after moving from Austin to San Antonio, sold Hope-pattern saddles to the U.S. Army for testing in 1857, five years after Hope's death, but the military never adapted the pattern (fig. 9).[22]

Hope-style trees were mounted with heavy leather and rigging for working cattle. While the Hope-pattern saddle continued to be advertised and sold in variations into the late 1800s, the large platter-style horns lost out to smaller horns used in the 1870s and 1880s that became the preferred Texas pattern well into the twentieth century.

In the late 1860s, a new version of a saddle came out of the brush in the lower Guadalupe River valley: the "Mother Hubbard" saddle, named for a one-piece woman's dress because of its full leather covering. The covering is called a *mochila* in Spanish and was widely used in Mexico. A number of 1870s images show saddles with mochilas. Bose Ikard, Charles Goodnight's right-hand cowboy, carried gold back to Texas from trail drives under his mochila.[23] Pony Express saddles featured a mochila with mail pockets attached. A Mother Hubbard saddle in the Witte Museum collection has repaired "fenders" on the stirrup leathers, one of which bears the mark "Otto Kraege, Runge, Texas" (fig. 10). Runge is in eastern Karnes County, and numerous cowboys and drovers worked in the area. The saddle may have been made much earlier in Yorktown, Texas, and the fender repair marked later by Kraege. The rounded horn came to be called an "applehorn."

Another applehorn saddle was presented to the Witte Museum in 1927 by the drover and stockman George Saunders (fig. 11). A worn-out relic, the saddle bears the mark of J. Stratton, Cuero, Texas, on the seat and was ridden up the trail on numerous trips in the 1870s and 1880s by the Boyce brothers. By the late 1870s, Texas saddlers had strengthened the saddletree designs of previous decades by eliminating cut-out slots for stirrup leathers.

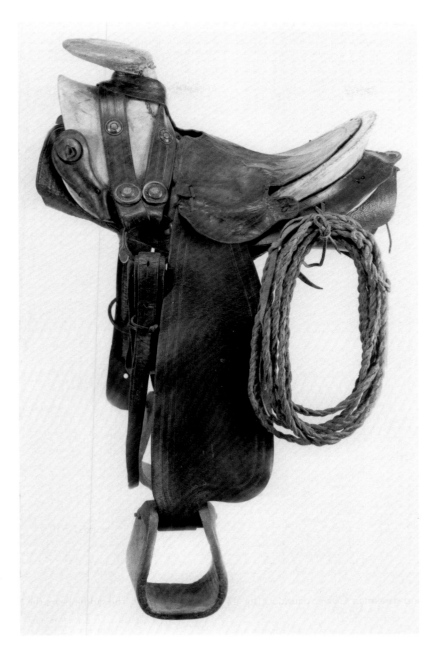

*Fig. 9. Maker unknown, Texas, **"Hope"-Style Saddle**, c. 1850s, leather, wood, brass, and iron, Donald and Louise Yena Collection, Witte Museum, San Antonio.*

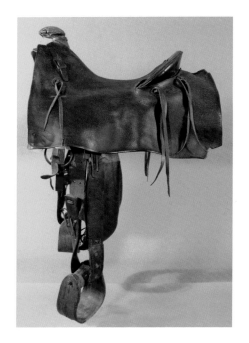

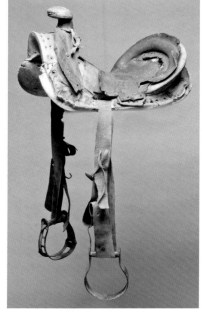

*Fig. 10. Otto Kraege, Runge, Texas, **Mother Hubbard** Saddle, c. 1870s, leather, wood, and iron, Witte Museum, San Antonio, gift of Jim B. Blakely.*

*Fig. 11. J. Stratton, Cuero, Texas, **Applehorn Saddle**, c. 1870s, leather, wood, and iron, Witte Museum, San Antonio, gift of George W. Saunders.*

Texas Leather Shops

Leather trappings of all kinds were made for cowboys and vaqueros. Saddles, breast collars, cinches, chaps, boots, spur leathers, wrist guards, and saddlebags were a few of the items made for them by craftsmen.[24] Early nineteenth-century Texas shops were one- or two-man operations supplying local stockmen. In 1850 there were fourteen saddleries listed in Texas census rolls,[25] with no saddlers in San Antonio and only a tree maker in New Braunfels, suggesting that local saddles were brought in from Mexico or from East Texas, where most saddlers were active. Unfitted saddletrees were bought and rigged by owners as well.

The number of Texas shops increased to fifty in 1860, with 117 saddle makers listed by 1870.[26] Bexar and Comal Counties combined had eleven saddle operations by that year.[27] Larger shops like E. Varga in San Antonio had over thirty employees, and by 1880 L. (Lazarus) Frank and Company and Dietrich Heye saddlery occupied large buildings in San Antonio, with a number of employees making saddles and tack for the cattle industry as well as filling U.S. Army contracts. L. Frank sold boots as well.[28]

The census numbers clearly reflect not just the state's increasing population but also growing livestock operations needing gear. Mechanization was occurring with the use of sewing machines in large saddleries, as opposed to the hand stitching still done in small shops. By 1880 there were 111 shops in Texas, fewer than in 1870, but more shops were mechanized with over two dozen employees. The majority of operations continued, however, as one- and two-man shops.[29]

Chaps: Thorn-Brush Protection

Chaps evolved from armas, a large shaped piece of leather attached to the front of the saddle and tied around the rider's waist with a braided leather cord. A version of armas called *armitas*, due to their smaller size, was still commonly used in the early 1800s in Texas, as evidenced in the Tapía watercolors.

The word *chaparreras* derived from the Spanish *chaparas* or *chaparral*, meaning heavy brush—from which these leather leggings protected the horseman. One of the earliest references to chaparreras was published in Mexico in 1844. As vaqueros also performed most of the heavy cattle work in the South Texas brush, they likely wore chaps, as the leather breeches were noted as being worn throughout northern Mexico.[30] Chaparreras made south of the Rio Grande usually showed better workmanship and fitting than their Texas counterparts. The wide heavy waistband on Mexican chaps protected the rider from fast-moving maguey ropes that could easily burn through the leather (fig. 12).

Used less than forty years after the armitas depicted by Tapía, the earliest chaps in Texas were seatless leather pants referred to as "shotgun" chaps. The heavy leather chaps, also called leggings or "leggins," protected the rider and his clothing from the sharp brush, cactus, and fast-moving ropes. The term "shotgun" refers to the straight parallel legs resembling gun barrels. Chaps were often fringed on the sides and laced with nickel or silver *conchos,* like the Mexican leather breeches preceding them (fig. 13).

Shotgun chaps were popular at the height of the trail drives in the 1870s and into the late 1880s. W. I. Wroe operated a saddle shop in Hallettsville, Lavaca County, Texas, and is listed in the Texas Special Census as producing a hundred saddles annually in 1860, but his company would have also made chaps. Lavaca County was a rapidly growing center of stock raising and produced nationally known drovers. Wroe later operated a large saddle shop in Austin, under the name W. T. Wroe and Sons, in the late nineteenth century and into the twentieth century.[31] Outside of brush country on the grassy plains, chaps were not always worn. The leather pants were hot and restrictive, and the protection offered to the wearer and his fabric trousers was not needed.

By the late nineteenth and early twentieth century, "batwing" chaps were the norm on ranches and later in rodeos (fig. 14). Batwing chaps had more open sides and were

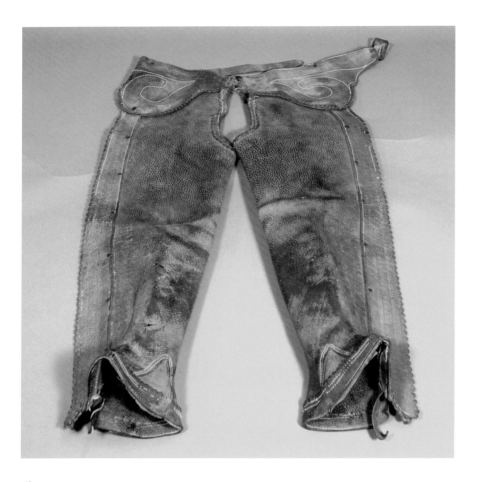

Above:
Fig. 12. Maker unknown, Mexico, **Chaparreras**, *c. late 1800s, leather and iron, Donald and Louise Yena Collection, Witte Museum, San Antonio.*

Opposite page, top to bottom:
Fig. 13. W. T. Wroe and Sons Saddlery in Austin, **Chaps**, *c. 1890s, leather and iron, Donald and Louise Yena Collection, Witte Museum, San Antonio.*

Fig. 14. Visalia Saddlery, San Francisco, California, **Chaps**, *c. mid-20th century, leather and nickel, Witte Museum, San Antonio, gift of Mrs. Helen M. Jones.*

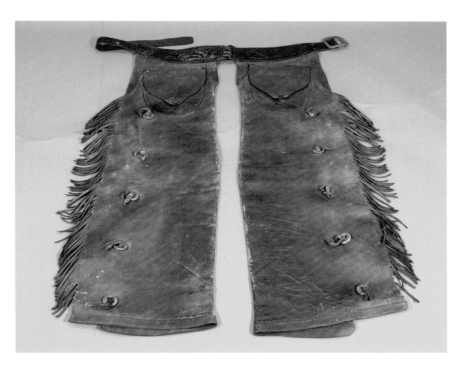

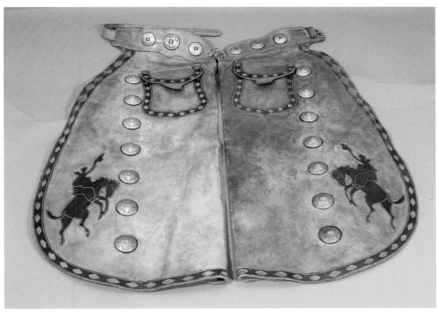

*Fig. 15. Maker unknown, **Espuela Grande Shank and Rowel**, c. 1600, iron, Witte Museum, San Antonio, gift of W. H. Taylor.*

much looser than their straight-legged counterparts. They were also easier to put on and take off. Batwing chaps are the preferred style today.

"I Can See by Your Outfit That You Are a Cowboy"[32]

Spurs

Spurs arrived in the Americas in two forms that corresponded to the styles of riding in practice: estradiota and la brida, which utilized spurs with spinning rowels on the rear,[33] and jineta, which used prick spurs originally from the Middle East. Roweled spurs, especially the *espuela grande*, or great spur, continued in use in New Spain, but the bulky heel extenders are said to have never reached Texas (fig. 15). However, the rusted shank and ten-inch rowel of an espuela grande is on exhibit at the Witte Museum, proving otherwise. The relic was found in the 1930s beside a natural lake, Espantosa, at what was once a campsite on the historic Camino Real near Carrizo Springs, Texas.

Except for parade and formal dress, spurs diminished in size throughout the Southwest after the 1600s. A groom was required to put large spurs on a mounted rider, and as the class structure of riding broke down in Mexico and New Spain, grooms were no longer employed. Like all other saddlery and tack, the realities of labor set the standards and needs of the horseman.

Fig. 16. Joseph Bianchi, Victoria, Texas, **Spurs**, c. late 1890s, iron and silver, Donald and Louise Yena Collection, Witte Museum, San Antonio.

Fig. 17. Kelly Brothers, El Paso, Texas, **Mexican-Pattern Spurs**, c. early 1900s, iron and nickel, Donald and Louise Yena Collection, Witte Museum, San Antonio, Texas.

Spurs were usually made by blacksmiths doing other work in addition to spur making through the mid-nineteenth century. The forging of branding irons, spurs, and bits and the repair of farm equipment were done in the same shop. By the 1870s, spurs were made in small shops throughout the Southwest and Mexico (fig. 16). By the 1880s, cheap spurs were shipped to Texas from factories in the northeast like August Buermann Company. As demand increased, shops in Texas cattle country were exclusively dedicated to making spurs and usually bits as well. The work was often divided into the following tasks: forging spur blanks, finishing and mounting the spurs with silver or nickel, and final engraving. The price depended upon the decoration, but Texas cowboys liked fancy spurs.[34] Most catalogs listed Mexican styles, as well as those preferred by Anglos, with names like "Chihuahua" and "Texas" (fig. 17).

Fig. 18. **Sombrero,** *Mexico City, c. 1870s, felt and silver thread, Witte Museum, San Antonio, gift of Peter A. Nowell.*

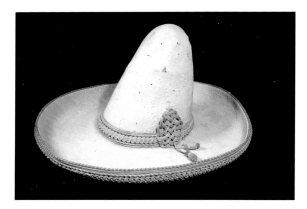

Fig. 19. **Peloncillo Sombrero,** *Mexico, c. 1880s–90s, felt, Donald and Louise Yena Collection, Witte Museum, San Antonio.*

Topping Off: Hats

In Texas and Mexico, horsemen chased cattle and wore hats until the headwear rotted from sweat in the Texas heat or fell apart from being used to feed and water both horses and riders. The finest sombreros in the nineteenth century were often made in Paris, France, as labels have shown. Tardan was one of the best hatters from the nineteenth century into the twentieth century. Mexican hatters produced nearly all of the woven straw and plant-fiber sombreros that made their way from Mexico to Texas, as they still do today. Crown shapes and heights changed, as did brim width, but the hat was still a sunshade. Felt was most often for winter use, and straw for summer use, as it still is.

A beautiful sombrero from the 1870s was purchased by the artist Thomas Allen and is fairly well documented by its shipping box (fig. 18). The low crown and wide brim were favored sporadically in Mexico from the eighteenth century through the late nineteenth century. The sombrero was purchased by Allen in Mexico City. The hat was sent overland from Mexico City to Veracruz, where it was shipped to Boston by American

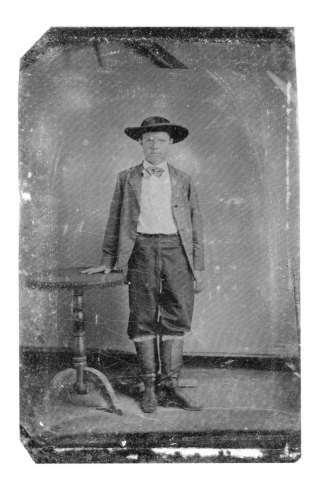

*Fig. 20. Unknown photographer, **Ike West,** Lavaca County, Texas, c. mid- to late 1860s, hand-colored tintype, quarter plate, Kittie West Burns Family Archives, Witte Museum, San Antonio.*

Express. In the twentieth century, the fine hat was delivered in its original box to the Witte Museum in San Antonio by a descendant of Allen's.

By the 1880s, high-crowned sombreros were popular and called *peloncillo,* as the crown resembles a cone of sugar. Bright and highly decorated when compared to a gray Stetson or a tan Southern "planter's" hat of the 1850s, the pictured sombrero is somewhat restrained in its decoration compared to sombreros made from red and black felt (fig. 19).

A few years before the Allen sombrero was produced, Ike West had his picture made in Lavaca County, Texas (fig. 20). Wearing his cowboy outfit in the mid- to late 1860s, Ike dons a hat with a low, rounded crown, like Mexican sombreros of the era. The boots were probably Texas-made. By the mid-1870s, Ike West was an important drover and cowboy in partnership with his brothers George and Sol.

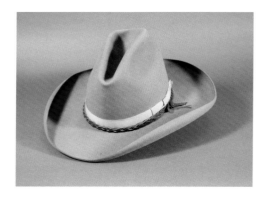

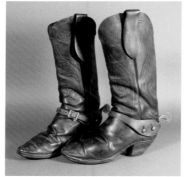

Above, left to right:
Fig. 21. John B. Stetson, **Stetson Cowboy Hat**, *Philadelphia, Pennsylvania, c. late 1800s, felt, Donald and Louise Yena Collection, Witte Museum, San Antonio.*

Fig. 22. **Mule-Ear Boots with OK Spurs**, *Texas, 1880s, leather, Donald and Louise Yena Collection, Witte Museum, San Antonio.*

Opposite page:
Fig. 23. Unknown photographer, **William Ralph Haynes**, *Blanco County, Texas, c. 1868–75, tintype, quarter plate, Lawrence T. Jones III Collection of Central University Libraries, Southern Methodist University, Libraries, Dallas.*

From the end of the Civil War onward, felt hats made by John B. Stetson of Philadelphia, Pennsylvania, dominated the Texas market (fig. 21). Exceptions were usually wide-brimmed military hats from the Civil War and hats made in Mexico. Hats depicted in photos of the 1860s and early 1870s show low crowns with wide brims and sometimes exotic-looking added decorations. Personalization done by the wearer included reshaping, a special hatband, or even inked decoration.

Boots

More than any other article of dress, boots shaped the identity of the cowboy. Whether worn by a stockyard worker or a Houston attorney, cowboy boots are symbolic footwear. Boots were made by small and large shops, throughout Texas and northern Mexico, in a plethora of shapes and styles (figs. 22, 23). Elaborate stitching stiffened the tops and, by the early 1870s, inlaid colored leather elevated the decoration. Boots have changed in heel heights, decoration, and colors, but they still represent their cowboy past.

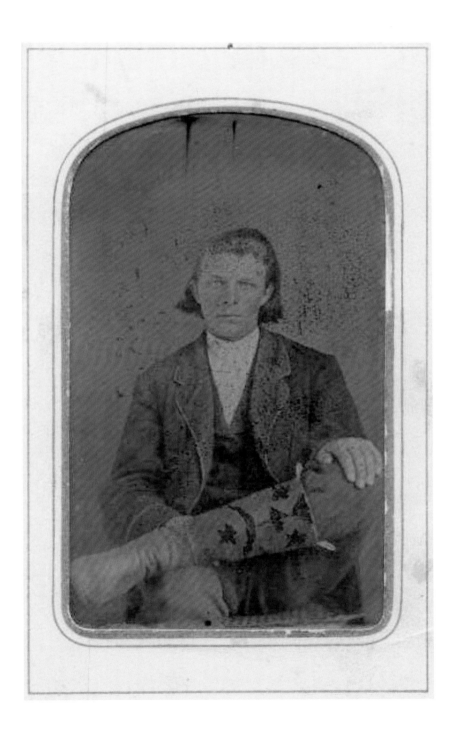

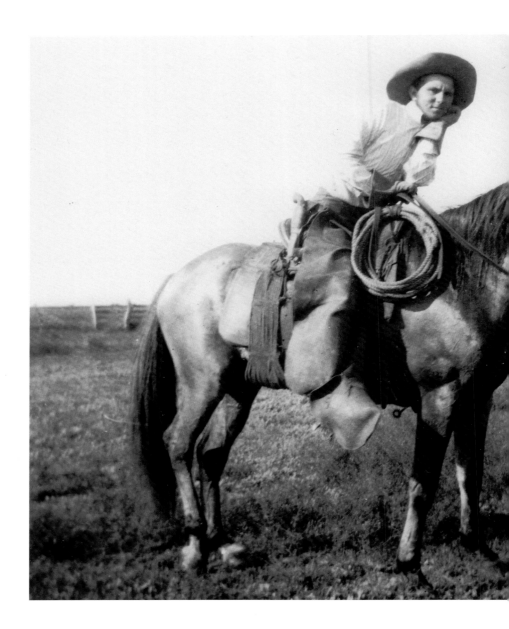

The Cowboy

By the late 1800s, the image of the Texas cowboy had spread across the nation and the world through newspapers, books, artworks, performances, and photographs, and from the late nineteenth through the present time, movies and later television have depicted

Fig. 24. Unknown photographer, **Albert West, Jr.**, *Lavaca County, Texas, c. late 1800s, silver copy print, Kittie West Burns Family Archives, Witte Museum, San Antonio.*

the character. The cattle herder arose to become a hero and defender of rights, and he roped a few steers on the side for effort. In Texas he could still perform the work of a skilled cowboy, using specialized tools that evolved in his home state (fig. 24).

Notes

1 Bernal Diaz, *The Conquest of New Spain*, trans. J. M. Cohen (London: The Folio Society, 1974), 46, 48.

2 António Galvão de Andrade et al., *Arte da Cavallaria de Gineta, e Estardiota, bom Primor de Ferrar, & Alveitaria*, 3rd ed. (Lisbon: Joam da Costa, 1678), unpaginated, plates 346, 347.

3 Kathleen Mullen Sands, *Charrería Mexicana* (Tucson: University of Arizona Press, 1993), 30–31.

4 Deb Bennett, *Conquerors: The Roots of New World Horsemanship* (Solvang, CA: Amigo Publications, 1998), 99.

5 Ibid., 99.

6 Ibid.

7 Sands, *Charrería Mexicana*, 25.

8 Mary Lou Compte, "The Hispanic Influence on the History of Rodeo, 1823–1922," *Journal of Sport History* 12, no. 1 (Spring 1985): 24.

9 John R. Erickson, *Catch Rope: The Long Arm of the Cowboy* (Denton: University of North Texas Press, 1994), 4.

10 A nineteenth-century rope-making stand for twisting maguey ropes still exists on the McAllen Ranch. Rawhide was hand-braided after the long strings were cut. Bill Dorrance and Randy Wieman, *Four Strands of Rawhide: The Making of a Reata*, parts 1 and 2 (N.p.: Quien Sabe Enterprises, 2000), VHS.

11 José "Pepe" Diaz of San Antonio and Boerne, Texas, tripped steers with the rope wound around his neck for Mexican President Lázaro Cárdenas in the main arena at Mexico City in the late 1930s.

12 Erickson, *Catch Rope*, 45.

13 Ibid., 61.

14 Richard E. Ahlborn, "European Dress in Texas, 1830: As Rendered by Lino Sánchez y Tapía," *American Scene* (Thomas Gilcrease Institute of American History and Art) 13, no. 4 (1972): 3.

15 Ibid.

16 The author has examined a matching pair of fringed pants and a jacket residing in the Witte Museum collection in San Antonio. They were bought in the late nineteenth century in El Paso, by the donor's ancestor.

17 Ahlborn, "European Dress in Texas, 1830," 49.

18 Ibid., 51.

19 Narris W. Braly, "Hope of Austin's Colony in Texas," *Burleson County, a part of TXGenWeb*, last modified 2010, accessed February 1, 2017, http://theusgenweb.org/tx/burleson/Biographies/hope.html.

20 Michael Rugeley Moore, *Austin Colony Origins of Hope Saddles* (unpublished manuscript, 1995), 7, 8.

21 "Legal Notice," *Semi-Weekly Star* (Washington, TX), September 9, 1850.

22 *State Gazette* (Austin), March 14, 1857; available online, *University of North Texas Libraries, The Portal to Texas History*, crediting the Dolph Briscoe Center for American History, accessed February 2, 2017, texashistory.unt.edu/ark:/67531/metapth81287/m1/4/.

23 J. Evetts Haley, *Charles Goodnight: Cowman and Plainsman* (Norman: University of Oklahoma Press, 1949), 242.

24 While the skills needed for making boots and shoes are similar to those used for saddles, boots and shoes were rarely produced in saddle shops, and the shops are listed separately on Texas census records of the era.

25 1850 U.S. Federal Census, Texas, Schedule 5, "Products of Industry," Special Census Records, NARA microfilm publication T1134, roll 45.

26 1860 U.S. Federal Census, Texas, Schedule 4, "Products of Industry," Special Census Records, NARA microfilm publication T1134, rolls 45–46.

27 1870 U.S. Federal Census, Texas, "Products of Industry," Special Census Records, NARA microfilm publication T1134, rolls 45–46.

28 Ibid.

29 1880 U. S. Federal Census, Texas, "Manufacturing," Special Schedules No. 3, NARA microfilm publication T1134, rolls 48–49.

30 Arthur Woodward, "The Evolution of the Cowboy's Chaps," *Los Angeles County Museum Quarterly* 8, nos. 3–4 (Spring 1951): 7–9.

31 1860 U.S. Federal Census, Texas, Schedule 4, "Products of Industry," Special Census Records, NARA microfilm publication T1134, rolls 45–46.

32 Marty Robbins, vocal performance of "Streets of Laredo," produced by Don Law, recorded March 1960 on *More Gunfighter Ballads and Trail Songs*, Columbia CS-8272, 33 ½ rpm.

33 Charles De Lacy Lacy, *The History of the Spur* (London: The Connoisseur, 1911), plates 24, 47. One of the earliest great spurs found was documented in 1785. The relic was dug up on the site of the 1471 Battle of Barnett, a site north of London, England.

34 There are so many published works on spurs, saddles, tack, and cowboy dress that the author suggests readers seek out publications on specific items discussed.

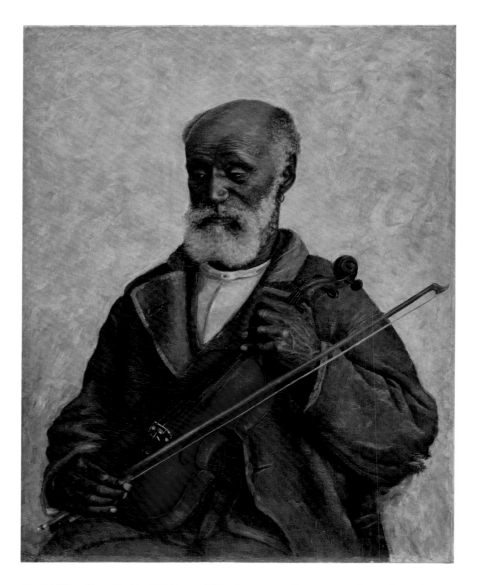

*Fig. 1. William Henry Huddle, **Old Slave**, c. 1889, oil on canvas, 35 ½ x 27 ½ in. (90.2 x 69.9 cm), Dallas Museum of Art, the Karl and Esther Hoblitzelle Collection, gift of the Hoblitzelle Foundation, 1987.43.*

Portraits of Slaves in a New South

Jennifer Van Horn

In 1889 the Texas artist William Henry Huddle, best known for his depictions of prominent politicians, approached an African American man named Mose, whom he had glimpsed walking down the street in Austin, and asked if he could paint his portrait (fig. 1). While inspired by Mose's appearance, Huddle had wanted to paint a person of this "type" for several years. Titled variously *The Slave* or *Old Slave*, his portrait of an elderly African American man appears at first unromanticized; raking light harshly illuminates the sitter's white beard, bald head, and wrinkled forehead. Mose is seated before an austere grayish-white background that contrasts dramatically with the sitter's skin to highlight his blackness. The scumbled backdrop is composed of the same paints that the artist used to construct the sitter's simple white shirt with a button collar. The rest of his dress is equally plain, consisting of an ill-fitting green coat and black pants. Mose's dress may be poor, but he clasps a shiny violin, or fiddle, his gnarled and deeply veined hands at its top and bottom providing a marked contrast to the smoothness of the instrument's polished wood surface. Mose does not play, but holds the fiddle gingerly across his torso. With his gaze downcast, he appears lost in memory, and one eye brims with what might be a tear.[1]

The simple composition and seeming realism of Huddle's painting is at odds with the deliberate effect that the artist, a Confederate veteran, intended to conjure: nostalgia for the antebellum South. In this portrait, Huddle staged his region's lost cultural ideals through the body of an aged black sitter. The painting's fictionality is epitomized by the violin, the central feature of the composition. This was not Mose's instrument, but rather a prop that the artist urged upon him. According to an account from the artist's daughter, when Huddle first asked his model to pose with the instrument, Mose declined

vehemently, declaring "No, suh, th' fiddl's the Devil's music box." The artist persisted, explaining that "angels in heaven played them, also the lyre, and harp." Upon hearing that, Mose acquiesced, responding, "Boss give me that fiddle."[2] Although Huddle staged his argument on religious grounds, it is unlikely that it was a Christian association he sought in his painting. As both Mose and Huddle knew, the fiddle had long been associated with enslaved musicians and the minstrel shows that both romanticized and lampooned African American culture. Certainly the banjo was the instrument most strongly connected to minstrelsy in popular culture, as immortalized in Eastman Johnson's *Confidence and Admiration* (c. 1859, fig. 2), a rendering of an elderly black musician and his young admirer that Johnson adapted for his famous work *Negro Life at the South* (1859, see pages 40–41). Along with the banjo, fiddles were one of a set of instruments that musicians played in minstrel shows. Fiddle solos were especially popular for plaintive songs in which performers expressed emotional loss: the death of wives and the sale of children.[3] Mose's sad expression and his fiddle, then, point not to an objective portrait of a stranger on the street but rather evoke minstrelsy. The loss that the painted Mose mourns might be the loss of the mythical plantation South that the minstrel show celebrated: the benevolent protection of a slaveholder who (according to slavery's apologists) would have protected Mose in his old age.

The elegiac nature of Huddle's work becomes clear through comparison to other paintings of black musicians and performers completed by northern artists about the same time. Thomas Eakins's *The Dancing Lesson* (1878, fig. 3) and Henry Ossawa Tanner's *The Banjo Lesson* (1893, Hampton University Museum, Hampton, Virginia) similarly feature aged black performers. These men, however, are active—playing the banjo or having just demonstrated a dance. They are not alone, a singular specimen, but rather are presented as part of a musical tradition that their teaching ensures will continue through the generations—in Tanner's painting through the boy just learning to pluck the banjo's strings, and in Eakins's watercolor through the teenager who strums a tune and the youth who dances before the older man's critical gaze. In these paintings, music and performance are presented as a balm and a source of strength for African Americans moving forward to citizenship. By contrast, in Huddle's *Old Slave*, Mose gains no agency—he is not shown playing music—but rather is simply in mourning. The fiddle of the minstrel show has been stopped. In his old age, quiet humility, and passivity, Mose appears to be cast in the model of the fictional character Uncle Tom. He resembles the many illustrations of white-haired and subservient Uncle Toms that accompanied posters for performances of Harriet Beecher Stowe's novel that toured the United States in the nineteenth and early twentieth centuries (fig. 4). Such images of elderly subservient black men could also be found more locally in the works of the Southern artist

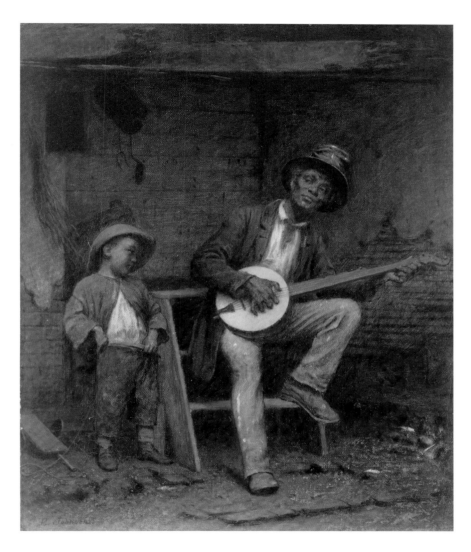

*Fig. 2. Eastman Johnson, **Confidence and Admiration**, c. 1859, oil on canvas, 11 ¼ x 9 ⅛ in. (28.6 x 23.2 cm), Mead Art Museum, Amherst College, Amherst, Massachusettes, museum purchase, AC 1958.48.*

William Aiken Walker. Although associated with Charleston, South Carolina, Walker painted briefly in Texas in the 1870s. This untitled depiction known as *Cotton Picker*, from the 1880s, is typical of Walker's many nostalgic portrayals of African American sharecroppers who, like Mose, bear white beards and downcast gazes, and might have sparked Huddle's desire to paint a sitter of this "type" (fig. 5).[4]

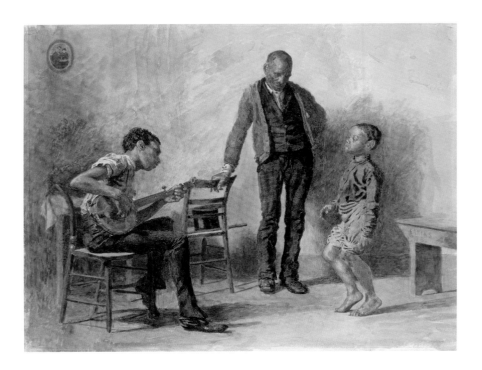

Fig. 3. Thomas Eakins, **The Dancing Lesson (Negro Boy Dancing)***, 1878, watercolor on wove paper, 18 ⅛ x 22 ⅝ in. (45.9 x 57.3 cm), the Metropolitan Museum of Art, Fletcher Fund, 1925, 25.97.1.*

Mose is presented in the painting as a slave or an "old slave," yet, when Huddle painted him, he was in reality neither. Mose was, of course, then a former slave: a freedman. It was only in Huddle's painting that he once again resumed his enslaved status. Mose's inability to play the violin, and thus to seamlessly assume the role that Huddle envisioned for him, highlights the divergence between Huddle's imagined South and the reality of post-Reconstruction Texas. We should ask to what extent Mose participated in the fantasy for which Huddle cast him. He sat willingly for the artist, raising concern only over the inclusion of a fiddle. Mose might have been, as he intimated, a devout Protestant who condemned the fiddle for its use at dances and the kinds of bodily, and sometimes sexual, freedom that could be unleashed at these events, particularly in a multiracial and multiethnic Texas. Or perhaps Mose's ignorance was feigned. He might have rejected the instrument as a way to limit the demeaning racial message of Huddle's portrayal. Perhaps, in Mose's mind, the fiddle conjured the stereotyped images of African American musicians that dominated popular prints and sheet music such as *Down South Where the*

Fig. 4. Illustrator unknown, **Uncle Tom's Cabin**, *theatrical poster, Buffalo, New York, Courier Litho. Co., c. 1899, lithograph, Library of Congress Prints and Photographs Division (LC-USZC4-10315), Washington, D.C.*

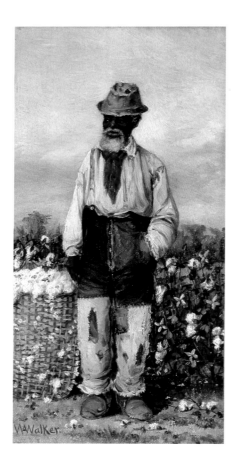

Sugar Cane Grows (1877), on the cover of which a white-bearded man plays the banjo
in front of a slave cabin while a group of enslaved people dance before him (fig. 6). The
first scholar to write about Huddle's portrait, Pauline Pinckney, speculates that Mose
agreed to hold a violin in order to ensure that he got paid. If so, Mose assumed the
minstrel stereotype only after registering his protest.[5]

Realistically painted but clouded with racial preconceptions, Huddle's portrayal
gives few clues to Mose's personal emotions. Did he long to be independent from such
nostalgia, or was he resigned to the illusion that he helped portray? The gold earring
that Mose wears in his left ear is the only hint of his personal identity. The fact that
Mose wore such jewelry speaks to his commitment to his personal appearance. His
clothes may have been ill-fitting and earth-toned, but the earring suggests that he

nevertheless maintained pride in his image. After emancipation, freedmen's manuals, penned by northern clergymen who sought to help former slaves adjust to freedom, discouraged such personal adornment. One manual preached, "You can not afford to spend money for useless dress and ornaments. You need tools, horses, plows, books, lands, education,—every thing, before costly rings, watch-chains, and expensive apparel.

Do not waste your earnings on your person." Mose defied such prescriptions, delighting in his new consumer power as a freedman even as he allowed himself to be cast in paint as an "old slave."[6]

Huddle's image of Mose is one of the last painted portraits from the postbellum South that purports to depict a slave. As such, it stands at the end of a long line of images commissioned by white Southerners that represented, as well as fictionalized, the bodies of the men and women they enslaved. These paintings were most commonly portraits of white masters or mistresses that featured enslaved attendants, a tradition that gained popularity in Great Britain and its American colonies in the seventeenth century alongside Atlantic settlement and the growth of the transatlantic slave trade. Pierre Mignard's 1682 depiction of the English Duchess of Portsmouth is an early metropolitan example (fig. 7). In Mignard's portrait, the duchess embraces her young enslaved attendant with an air of both familiarity and possession. Southern planters, eager to showcase their gentility in terms that would resonate across the polite British Atlantic world, also included slaves in their portraits. One of the most well-known is John Hesselius's depiction of Charles Calvert of Maryland. In this painting, the boy stands next to an unidentified enslaved attendant who kneels, supporting his young master's drum (fig. 8).[7]

Whether Pierre Mignard and John Hesselius modeled these attendants on actual body servants enslaved by the Duchess of Portsmouth and the Calvert family is not known. What is clear is that, in his rendering of a Maryland slaveholder and member of the colonial aristocracy, the American-born artist Hesselius looked to Europe and paintings such as Mignard's for artistic cues. In Mignard's portrait, the enslaved child proffers a piece of coral and a cache of pearls (both Caribbean products) from a seashell; the child's gaze is fixed anxiously on the duchess's face, awaiting her approval. In Hesselius's painting, the enslaved boy similarly offers his master an object, in this case a drum, and—as in the English portrait—Calvert's attendant looks up at his master, trying to anticipate the boy's needs. The dark skin of both slaves reflects their position as exotic commodities, similar to those grasped by the child whom Mignard depicted. This enslaved child's luxurious costume with elements of Eastern dress heightens her association with tropical commodities such as tea, sugar, and tobacco, a suggestion intensified by the frequent use of African slaves on trade cards for those who sold these luxuries. In one London example, *Sancho's Best Trinidado* (fig. 9), a Native American smokes a pipe in the foreground while an enslaved African gathers tobacco leaves at the back right. Hesselius's painting recasts the opulent foreign-inflected costume in Mignard's painting as livery, an expensive form of dress worn by enslaved waiters and attendants around the British Atlantic that echoed the cut of a fashionable man's suit, but was created in the family's colors, in this case gold and black.[8]

Fig. 7. Pierre Mignard, **Louise de Keroualle, Duchess of Portsmouth, with an Unidentified Servant**, 1682, oil on canvas, 47 ½ x 37 ½ in. (120.7 x 95.3 cm), National Portrait Gallery, London, Purchased, 1878, NPG 497.

Above:
Fig. 8. John Hesselius, **Charles Calvert and His Slave**, *1761, oil on canvas, 50 ¼ x 39 ⅞ in. (127.6 x 101.3 cm), Baltimore Museum of Art, gift of Alfred R. and Henry G. Riggs, in memory of General Lawrason Riggs, 1941.4.*

Opposite page:
Fig. 9. Anonymous, **Sancho's Best Trinidado**, *London, 1775–80, etching, 2 x 3 in. (5.1 x 7.6 cm), British Museum, London, D, 2.3977.*

British and early American patrons pursued a similar goal with these paintings: use of the visual field to proclaim slavery a key part of the white subject's identity and of the collective identity of the empire as a whole. Through their depictions of enslaved domestic workers, seventeenth-century British artists and patrons sought to naturalize their new position as owners of human property and as the beneficiaries of imperial expansion. Eighteenth-century American portraits similarly allowed Southerners to argue for slavery's centrality to the economic success of early America. Increasingly by the end of the eighteenth century in England and in the northern parts of the United States, however, featuring bondpeople in portraits of slaveholders became unpopular. As humanitarian outcries against the slave trade escalated, English and Northern consumers ceased commissioning portraits that featured slaves. Yet, in the American South, this tradition persisted. By the middle of the nineteenth century, it effloresced in the "cotton South"—areas newly settled by Anglo-Americans in the nineteenth century and brought into a system of plantation monoculture for the production of cotton and sugarcane. It is at first surprising that antebellum planters commissioned representations that were out of step with European taste, since elite Southerners were acutely aware of European fashion, going on grand tours and purchasing European landscape and history paintings as well as plaster casts of classical sculptures.[9] What led Southern planters to eschew European modes of art patronage when it came to representations that included enslaved people?

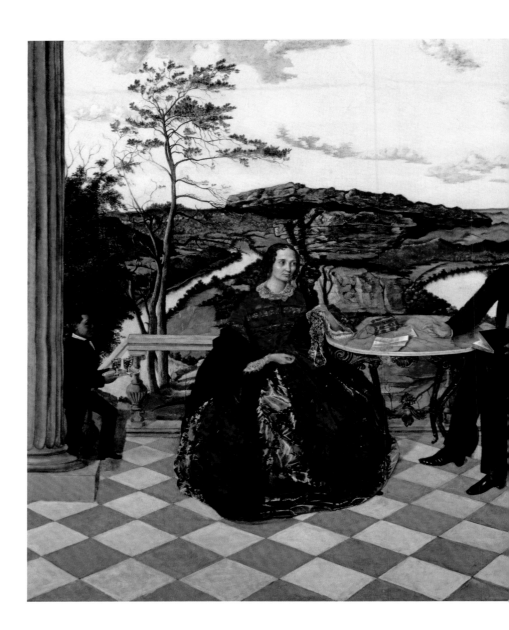

We can begin to answer this question by looking at a portrait by the artist James Cameron of the Tennessee politician and slave owner James A. Whiteside and his wife, shown posed on a high outcropping above the city of Chattanooga, where Whiteside

Fig. 10. James Cameron, **Col. and Mrs. James A. Whiteside, Son Charles, and Servants,** *c. 1858–59, oil on canvas, 53 x 75 in. (134.6 x 190.5 cm), Hunter Museum of American Art, Chattanooga, Tennessee, gift of Mr. and Mrs. Thomas B. Whiteside, 1975.7.*

was mayor. An enslaved waiter on the left attends to the couple, while in the foreground an enslaved nanny comforts the Whitesides' toddler son (fig. 10). Cameron's portrait is in many ways a reverential restaging of earlier American paintings, such as John Hesselius's.

Left:
Fig. 11. James Cameron, **Col. and Mrs. James A.**
Whiteside, Son Charles, and Servants, *detail.*

Opposite page:
Fig. 12. James Cameron, **Col. and Mrs. James A.**
Whiteside, Son Charles, and Servants, *detail.*

The Whitesides are seated around a central table that has been placed on a checkered veranda flanked on either side by Greek columns. The kneeling male attendant in Hesselius's painting has been replaced by a young waiter who leans against a pillar to the family's left, holding a tray with two silver goblets (fig. 11). In the right foreground, an enslaved woman, identified by family history as Jane, a nanny who cared for the Whitesides' nine children, holds one of them (fig. 12). Both bondpeople have brown skin, the young boy's a mahogany color, whereas Jane's is so light as to allow her to be mistaken for white upon first glance. In a radical departure from earlier paintings such as Mignard's, which privileged dark skin, by the 1850s artists had begun to reflect the higher value that Southern planters afforded mixed-race enslaved people. Jane's presence might reflect the prevailing taste for making light-skinned, attractive enslaved women domestic workers. However, her skin color also raises the question of whether Jane was genetically related to the Whitesides.[10]

The artist's choice to include Jane and the unidentified waiter might have been based on personal observation of the family and the enslaved people who labored for them. Cameron was a close family friend who relied on James Whiteside as his primary patron. The planter lured the Scottish-born and Philadelphia- and Europe-trained artist to Chattanooga from Nashville by offering him free lodging and a studio in the family's

guesthouse. Indeed, Cameron might have based the grouping of Jane and a child at the front right of the painting on a family photograph. Photographs of enslaved women and the children they tended, such as this ambrotype of an unidentified enslaved nanny with her white charges (fig. 13), gained popularity in the South as photography became more readily available.[11] The use of a source image could explain the disjuncture in scale between Jane and the rest of the figures depicted.

Whiteside's family portrait enabled him to connect himself and his family virtually to the plantation South that he had left behind in their move to Tennessee. In the painting, they literally cast themselves in the pose of earlier Southern planters, claiming their American right to own slaves, just as the Calverts had before them. In addition to colonial examples, Cameron might have had popular history paintings in mind as he approached the Whiteside portrait. In 1859, for instance, the artists Thomas Rossiter and Louis

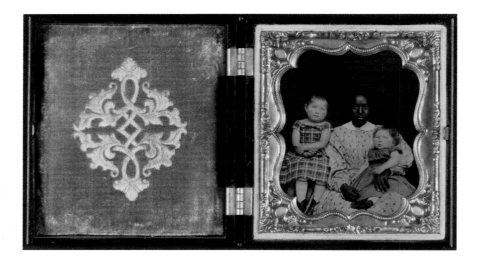

Above:
Fig. 13. Holmes, Booth & Haydens, **African American Woman with Two White Children,** *1860s, hand-colored ambrotype, 9 x 7 in. (22.9 x 17.8 cm), Cornell University Special Collections, Ithaca, New York.*

Opposite page, top to bottom:
Fig. 14. Thomas Pritchard Rossiter and Louis Remy Mignot, **Washington and Lafayette at Mount Vernon, 1784 (The Home of Washington after the War),** *1859, oil on canvas, 87 x 146 ½ in. (221 x 372.1 cm), the Metropolitan Museum of Art, New York, New York, bequest of William Nelson, 1905, 05.35.*

Fig. 15. Thomas Oldham Barlow after Rossiter and Mignot, **The Home of Washington,** *c. 1870, engraving, 25 x 33 ½ in. (64 x 85.5 cm), Library of Congress Prints and Photographs Division (LC-DIG-pga-00130), Washington, D.C.*

Mignot completed a monumental history painting titled *Washington and Lafayette at Mount Vernon, 1784* (fig. 14). In this work, George Washington and the Marquis de Lafayette are similarly posed on a portico, in this case that of Washington's Virginia plantation, Mount Vernon. An enslaved nanny and Washington's adopted grandson, George Washington Parke Custis, are seated on the steps before them, recalling Cameron's similar grouping. Rossiter and Mignot's painting, as well as other similar works, became well known through engravings such as Thomas Oldham Barlow's (fig. 15), and thus might have provided inspiration for the Tennessee artist.[12]

The similarities between Cameron's portrayal of the Whiteside family and Rossiter's romanticized depiction of George Washington suggest the role that imagination continued to play in portrayals of enslaved attendants in the nineteenth-century South. As Maurie McInnis has detailed, Rossiter and Mignot's glowing picture of eighteenth-century

plantation life made a strong political argument. In the decades between 1820 and 1860, slavery expanded into new parts of the United States as Southern slaveholders in pursuit of land for growing cotton moved further south and west into Tennessee, Alabama, Mississippi, and Texas. With greater numbers of Northerners beginning to question the inhumanity of the institution and the wisdom of expanding it into new territories, Southerners claimed George Washington for their own, eager to visually remind Americans of the first president's slaveholding past. Such images of Washington the planter held meaning for many slaveholders, but they likely held special importance for those Southerners who moved into new western territories, where they attempted to re-create an idealized aristocratic slaveholding culture from the ground up.[13]

Southerners who expanded west brought familiar forms of art and architecture with them, along with the people they enslaved. James Whiteside, for instance, arrived in Chattanooga only a few years after the land became available, thanks to the federal government's forced removal of the Cherokee. The slaves he carried with him purportedly built his substantial brick house, the first brick building in the city. Whiteside quickly claimed financial and governmental power in the burgeoning town, not only serving as state representative and mayor but also playing a crucial role in joining Chattanooga to major transportation routes: he built a turnpike and strongly encouraged the Nashville and Chattanooga Railroad to come to the fledging city, an action commemorated in the painting by the train visible on the far right (fig. 16). By connecting the Whiteside family to a specific locale, Cameron's canvas argues for the naturalization of slavery

Fig. 16. James Cameron,
*Col. and Mrs. James A. Whiteside,
Son Charles, and Servants, detail.*

on the landscape, as Hesselius's earlier portrait had done. Hesselius's painting likely shows Calvert and his enslaved attendant posed before a church located near the family plantation, Mount Airy. Cameron's portrait likewise locates the family and their enslaved attendants distinctly in Tennessee, where slavery had become a contested institution. The first white settlers who came into the territory in the 1780s brought enslaved people with them, but slavery was protested in the eastern part of the state, where fewer white Tennesseans owned slaves, and where abolitionists gained a foothold in the nineteenth century. In light of these disputes, the political message of the Whiteside portrait becomes clear. Visible just over and beyond Jane's form, the glistening landscape of Chattanooga testifies to the wealth that slavery created and would contribute to the state's future economic prosperity. The new railroad only heightened the movement of commodities (grain and animals), goods (manufactured luxuries), capital, and people into this Southern state. In his portrait, Whiteside positioned himself not only as the heir of a colonial slaveholding legacy, but also as amassing more power and profit than earlier Southern planters would have dreamed possible through the cultivation of cotton and the infrastructure of the railroad.[14]

Enslaved people both helped to construct the railroad and were one of the commodities transported by rail. Slave traders welcomed the chance to move bondpeople more quickly and efficiently than the multiweek slave coffle, turning to the railroad to meet cotton planters' demand for labor. Between 1820 and 1860, the interstate slave trade funneled some 700,000 enslaved people from the upper South to the lower South. The British painter Eyre Crowe depicted the scene in Richmond, Virginia, during his visit to the city, as bondpeople were brought by wagon to the railroad station, loaded onto railcars like the one visible in the background, and sent south to places such as Tennessee (fig. 17). As Crowe described in his 1893 memoir: "After the sales, we saw the usual exodus of negro slaves, marched under escort of their new owners across the town to the railroad station where they took places and 'went South.' They held scanty bundles of clothing, their only possessions. These were the scenes which, in a very short number of years, made one realize the sources of the fiercest of Civil Wars." Crowe recognized that cotton planters' desire for slaves was seemingly limitless: as profits for cotton soared, they required ever more slaves to enhance their earnings, despite the human or political cost.[15]

Of course, Anglo-American slaveholders in the cotton South did not move into landscapes devoid of past settlement or ideas about slavery. Particularly in places like Texas, planters sought to impose Anglo-American ideals amid a multiethnic population accustomed to Spanish imperial rule within which racial boundaries and legal categories had been more fluid. Eighteenth-century *casta* paintings by Mexican artists help to

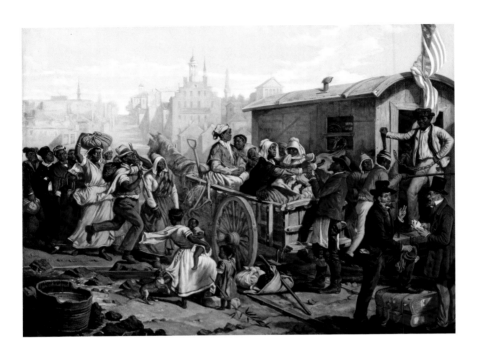

Above:
Fig. 17. Eyre Crowe, **After the Sale: Slaves Going South from Richmond,** *1853, oil on canvas, 27 x 36 in. (68.6 x 91.4 cm), Chicago History Museum, ICHi-66786.*

Opposite page:
Fig. 18. Jose de Alcibar, **De Espanol y Negra, Mulato [From Spaniard and Black, Mulatto],** *c. 1760, oil on canvas, 30 ⅝ x 38 ¾ in. (77.8 x 98.4 cm), Denver Art Museum, gift of the Collection of Frederick and Jan Mayer, 2014.217.*

recapture some sense of the complex racial network into which Anglo-Americans sought to insert their ideas in lands previously (or concurrently) inhabited by Mexican settlers (fig. 18). On the surface, these paintings seem to set forth a strict racial taxonomy: a "Spaniard," an "Indian," and their offspring; an "Indian," a "black person," and their offspring. As scholars have argued, however, these canvases simultaneously recorded the heterogeneity of settlement and the contextual nature of race. Whether someone was "Indian" or "Spanish" or "black" depended not only on their skin tone and visible racial characteristics but also how they were perceived within their own communities. The differences among races as understood by Anglo-American planters and Tejano settlers are evident in comparing the Whitesides' portrait to the casta painting. The enslaved Jane's light skin marks her as clearly mixed-race, yet she appears in the unequivocal role of an enslaved person tending to the needs of a white slaveholder. Jane's headscarf and

subservient pose, seated on the floor before her white master and mistress with her head bent down, inscribe her enslaved status. Legally, she is property, whereas the white boy she holds in her lap—one who may even be genetically related to her—is considered a full human being. Similarly, in the casta painting, a mixed-race person attends to a white person, but the figure's legal and social status is uncertain; the "mulatto" boy's mother appears to be a slave—but is he also? He waits upon his father, holding up a brazier for the Spaniard to light a cigarette, but it is not clear whether he does this as a domestic worker or as the man's attentive child.[16] As Southern planters brought slaves into the northern part of Mexico beginning in the 1820s, many Mexicans lobbied for abolitionist legislation. The unclear legal fate of slavery in borderlands like Texas lent confusion to the clearcut distinctions that Anglo-American planters sought between "slave" and "free."[17] In response to this racial incertitude, Anglo-Southerners turned to the material and visual world to assert their worldview. With their portraits of bondmen and bondwomen, nineteenth-century Southerners wanted to impress one another as well as the French, Spanish, or Mexican residents who inhabited the lands they settled.

Planters had an additional audience in mind for these paintings: the men, women, and children whom they enslaved. In June 1937, members of the Federal Writer's Slave

Fig. 19. **Daphne Williams, Age about 100**, *1936–38, photograph, United States Work Projects Administration (USWPA), WPA Slave Narrative Project: Container, A932, vol. 16, part 4, Manuscript Division, Library of Congress, Washington, D.C.*

Project interviewed and photographed Daphne Williams of Beaumont, Texas (fig. 19). Williams, they estimated, was then "close to or over 100." Born a slave near Tallahassee, Florida, she moved to Texas along with her owners, the Herring family, before the outbreak of the Civil War. Among her strongest memories of slavery were the family portraits inside their plantation house near Hillister, Texas. As she described in her interview, "They have they ownself painted in pictures on the wall, jus' as big as they is. They have them in big framce like gold." Williams's observations about looking at her owners' portraits force us to confront these now-missing paintings through the eyes of the men and women enslaved by the portraits' subjects, who also gazed upon the images displayed in their masters' houses.[18]

Of course, enslaved people left little evidence behind of their viewership of slave-holders' portraits, some of which included depictions of enslaved figures. Yet one can imagine the emotional impact that these paintings might have had on an audience of bondpeople.[19] Enslaved men, women, and children, uprooted from communities in the upper South and transported by railway, found themselves unmoored in new locations with other individuals who had also been sold away from everything familiar. To slave-holders, such an enslaved population was dangerous in that it lacked the generational ties that often encouraged compliance. Masters might have hoped that, as enslaved domestic servants stared at images of subservient slave attendants while they set tables, dusted parlors, and opened the door for guests, these paintings would inculcate the viewers' status as property and remind them of planters' continued hegemony in a new locale with a new cohort of fellow slaves. Images of compliant slaves potentially reinforced slaveholders' power in anticipation of enslaved peoples' rebellious behavior. These pictures reminded black viewers that, despite the shifting landscape, enslavement remained.

In the post–Civil War South, masters faced a new racial system composed of freed-men and freedwomen. They, not surprisingly, turned once again to the centuries-long tradition of painting and viewing portraits of enslaved individuals as a means to assert the place of white elites in the world. With this in mind, William Henry Huddle's image of Mose, in comparison to the other portraits considered, is notable in that the white master is left out of the picture entirely. Mose occupies the frame alone. Like the institution of slavery itself, Mose's master has been removed. Yet while the slave owner is hidden from the viewer's gaze, he or she still lingers in Huddle's title *Old Slave* or *The Slave*. Whereas nothing inside the frame would alert us to Mose's former enslavement, this textual linkage continues to insist on Moses's prior status as property. With the directive of Huddle's title, viewers position themselves in relation to Mose as a slave: looking down upon the seated figure with his silent violin, we are encouraged to perceive him as property, as a white master once did, and to mourn along with him that master's

loss. Huddle's painting reminds us that, with the end of slavery, the black body once again became a means for white artists and patrons to stage their own fantasies of status and domination.[20]

Notes

1 Pauline A. Pinckney, *Painting in Texas: The Nineteenth Century* (Austin: University of Texas Press for the Amon Carter Museum of Western Art, Fort Worth, 1967), 196. Sam DeShong Ratcliffe, *Painting Texas History to 1900* (Austin: University of Texas Press, 1992), 42–44.

2 Pinckney, *Painting in Texas*, 196.

3 Robert B. Winans, "Early Minstrel Show Music, 1843–1852," in *Inside the Minstrel Mask: Readings in Nineteenth-Century Blackface Minstrelsy*, ed. Annemarie Bean, James V. Hatch, and Brooks McNamara (Hanover, NH: Wesleyan University Press, 1996), 141–62, esp. 142.

4 Patricia Hills, "Painting Race: Eastman Johnson's Pictures of Slaves, Ex-Slaves and Freedmen," in *Eastman Johnson Painting America*, ed. Teresa A. Carbone and Patricia Hills (New York: Rizzoli, 1999), 121–65. Martin A. Berger, *Man Made: Thomas Eakins and the Construction of Gilded Manhood* (Berkeley: University of California Press, 2000), 30–40.

5 Melva Wilson Costen, *In Spirit and in Truth: The Music of African American Worship* (Louisville, KY: Westminster John Knox Press, 2004), 145. Pinckney, *Painting in Texas*, 196.

6 Shane White and Graham White, *Stylin': African American Expressive Culture from Its Beginnings to the Zoot Suit* (Ithaca, NY: Cornell University Press, 1998). Clinton Bowen Fisk, *Plain Counsels for Freedmen: In Sixteen Brief Lectures* (Boston: American Tract Society, 1866), 17.

7 David Bindman and Helen Weston, "Court and City: Fantasies of Domination," in *The Image of the Black in Western Art*, vol. 3, *From the "Age of Discovery" to the Age of Abolition*, part 3, *The Eighteenth Century*, ed. David Bindman and Henry Louis Gates, Jr. (Cambridge, MA: Belknap Press of Harvard University Press, 2011), 125–70. Paul Erickson, "Invisibility Speaks: Servants and Portraits in Early Modern Visual Culture," *Journal for Early Modern Cultural Studies* 9, no. 1 (Spring/Summer 2009): 23–61. Richard H. Saunders and Ellen G. Miles, *American Colonial Portraits: 1700–1776* (Washington D.C.: Smithsonian Institution Press, 1987), 251–52.

8 Susan Dwyer Amussen, *Caribbean Exchanges: Slavery and the Transformation of English Society, 1640–1700* (Chapel Hill: University of North Carolina Press, 2007), 191–216. Catherine Molineux, *Faces of Perfect Ebony: Encountering Atlantic Slavery in Imperial Britain* (Cambridge, MA: Harvard University Press, 2012), 18–60, 146–77. Linda Baumgarten, *What Clothes Reveal: The Language of Clothing in Colonial and Federal America* (New Haven, CT: Yale University Press for the Colonial Williamsburg Foundation, 2002), 128–34.

9 Agnes Lugo-Ortiz and Angela Rosenthal, *Slave Portraiture in the Atlantic World* (Cambridge: Cambridge University Press, 2013). Maurie McInnis and Angela Mack, *Pursuit of Refinement: Charlestonians Abroad 1740–1860* (Columbia: University of South Carolina Press, 1999).

10 William T. Henning, Jr., *A Catalogue of the American Collection, Hunter Museum of Art* (Chattanooga, TN: Hunter Museum of Art, 1985), 35–37. Kay Baker Gaston, "The Remarkable Harriet Whiteside," *Tennessee Historical Quarterly* 40, no. 4 (Winter 1981): 333–47.

11 Henning, *Catalogue of the American Collection*, 35–36. Laura Wexler, *Tender Violence: Domestic Visions in an Age of U.S. Imperialism* (Chapel Hill: University of North Carolina Press, 2000), 52–93.

12 Maurie D. McInnis, "The Most Famous Plantation of All: The Politics of Painting Mount Vernon," in *Landscape of Slavery: The Plantation in American Art*, ed. Angela D. Mack and Stephen G. Hoffius (Columbia: University of South Carolina Press for the Gibbes Museum of Art / Carolina Art Association, 2008), 86–114, esp. 102–4.

13 Ibid.

14 Saunders and Miles, *American Colonial Portraits*, 252. Gaston, "The Remarkable Harriet Whiteside," 116–17. Aaron Wagner Marrs, *Railroads in the Old South: Pursuing Progress in a Slave Society* (Baltimore: Johns Hopkins University Press, 2009).

15 Eyre Crowe, *With Thackeray in America* (London: Cassell and Co., 1893), 136. Maurie D. McInnis, *Slaves Waiting for Sale: Abolitionist Art and the American Slave Trade* (Chicago: University of Chicago Press, 2011), 145–54. Sven Beckert, *Empire of Cotton: A Global History* (New York: Alfred A. Knopf, 2015), 98–135.

16 Rebecca Earle, "The Pleasures of Taxonomy: Casta Paintings, Classification and Colonialism," *William and Mary Quarterly* 73, no. 3 (July 2016): 427–66.

17 Andrew J. Torget, *Seeds of Empire: Cotton, Slavery, and the Transformation of the Texas Borderlands, 1800–1850* (Chapel Hill: University of North Carolina Press, 2015), 259.

18 Daphne Williams Interview, *Federal Writers' Project: Slave Narrative Project*, vol. 16, *Texas*, part 4, *Sanco-Young*, 1936, manuscript/mixed material, retrieved from the Library of Congress, https://www.loc.gov/item/mesn164 (accessed May 22, 2017).

19 Enslaved viewership of artworks in the plantation South is explored in my current book project, *Painting Slaves: Intersections of Slavery and American Art, 1720–1880* (manuscript in progress).

20 Darcy Grimaldo Grigsby, "Negative-Positive Truths," *Representations* 113, no. 1 (Winter 2011): 16–38.

Contributors

Kenneth Hafertepe is chair of the museum studies department at Baylor University in Waco, Texas.

Rowena Houghton Dasch is executive director at the Neill-Cochran House Museum in Austin.

Serena Newmark is a PhD candidate at the University of Exeter, United Kingdom.

Bruce M. Shackelford is curator of South Texas Heritage at the Witte Museum in San Antonio.

Jennifer Van Horn is assistant professor, art history and history, at the University of Delaware in Newark.

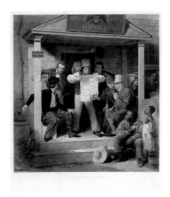

Above and left (detail):
*Alfred Jones, after Richard Caton Woodville, printed by J. Dalton and published by American Art Union, New York, **Mexican News**, c. 1851–53, engraving with watercolor hand coloring on wove paper, 20 ⅝ x 18 ⅜ in. (52.4 x 46.7 cm), the Museum of Fine Arts, Houston, the Bayou Bend Collection, museum purchase funded by Louis K. Adler in honor of Meredith J. Long, in celebration of the North American Free Trade Agreement, at "One Great Night in November, 1993," B.93.26.*

Photograph Credits

The Paintings of Hermann Lungkwitz as a Type of Texas Material Culture
Kenneth Hafertepe
Figs. 9, 15: Photograph by the author.
Figs. 14, 17, 21: Courtesy the Texas Collection, Baylor University.

From the Palaces of Berlin to the Texas Frontier:
The Furniture Designs of Prussian Architect Karl Friedrich Schinkel
Serena Newmark
Figs. 1, 2: Photograph by Wolfgang Sievers.
Fig. 3: Photograph by Damerau (first name unknown).
Fig. 4: Photograph by Babette Fraser Warren.
Courtesy of the University of Texas Press © 2012.
Fig. 6: Courtesy of the University of Texas Press © 2012.
Figs. 5, 7, 9: Photograph by Harvey Patteson.
Courtesy of the University of Texas Press © 2012.
Fig. 8: Photograph by Lore Müller.

Portraits of Slaves in a New South
Jennifer Van Horn
Fig. 1: Image courtesy Dallas Museum of Art.
Fig. 2: Bridgeman Images.
Fig. 7: © National Portrait Gallery, London.

Left: Bayou Bend's north facade as viewed from Clio Garden. Photograph by Rick Gardner.